CW00520408

The Na
3 PEAK!

The Official Challenge Guide

5th Edition

BEN NEVIS - SCOTLAND
SCAFELL PIKE - ENGLAND
SNOWDON - WALES

ONE BOOK COVERING 3 MOUNTAINS
Also including information on the
4th Peak – Slieve Donard - N. Ireland
5th Peak – Carrauntoohil - S. Ireland

An essential guide to help you complete the National 3 Peaks Walk

Brian G Smailes

Acknowledgements

It is with thanks to the following people for assistance, that this book has been published:

Graphic Design - Jamie Mann

Technical advice - Michelle England

Clothing & Equipment - supplied by 'Kathmandu'
- Alopex Jacket incorporating the Recco safety system (cover photo)
- 32 Lt Nowaki Day Pack (cover photo)

Brian Smailes is identified as author of this book in accordance with Copyright Act 1988. No part of this publication may be reproduced by any means without prior permission in writing from the publisher.

First Published 1996
Second Edition 2000
Third Edition 2005
Fourth Edition 2009
Fifth Edition 2016
ISBN 978-1-903568-74-3

Published by Challenge Publications,
7, Earlsmere Drive, Ardsley, Barnsley, S71 5HH.
www.chall-pub.co.uk

About the Author

Brian Smailes holds the record for the fastest 4 and 5 continuous crossings of the Lyke Wake Walk over the North York Moors. He completed the 210 miles over rough terrain on 5 crossings in June 1995 taking 85 hours 50 minutes. In 2014 he completed his 55th crossing.

In August 2001 Brian cycled from Lands' End to John O'Groats, a journey of over 910 miles in 6 days 13 hours 18 minutes. This involved carrying food, clothing and tent, and was completed without support. In August 2003 he walked from John O'Groats to Lands' End completing it in 32 days.

On a 2005 expedition, Brian walked the Inca Trail in Peru, visiting Lake Titticacca and Bolivia while in the area.

Another cycle ride, this time from John O'Groats to Lands' End took place in July 2007 to complete the two way cycle crossing.

Another expedition in 2007 to the Great Wall of China involved walking sections in remote areas along the former borders of Mongolia.

An expedition in 2008 took him to the jungle around Canaima in Venezuela, exploring on foot and by dugout canoe the tributaries of the Rio Carrao up to Angel Falls.

In 2010, Brian was part of a team on an expedition to Chile and the mountains of Patagonia, exploring the flora and fauna and the glacial impact on the region.

In May 2011, Brian cycled from Paris to London then later in the year walked the GR20 in Corsica.

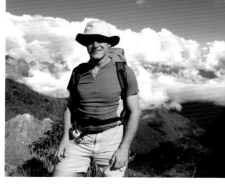

A second Great Wall expedition in remote regions of China took place in 2013 again on the border with Outer Mongolia.

His next expedition will take him to Iceland on one of the 20 best hikes in the world to explore the glaciers and the infamous volcano crater of the ash cloud of 2012 fame!

In 2016, Brian plans to walk from Land's End to John O'Groats to enable him to achieve his lifetime goal of walking and cycling the UK end to end both ways.

Brian lives in Yorkshire but is currently walking sections of the UK coastline. He has completed Berwick to Spurn Point as well as other sections around the UK.

Having travelled extensively throughout the UK, Europe and the Caribbean, Brian has also written international travel guides to enable the holidaymaker to access the world with ease and enjoy it as much as he does.

Marathon running, canoeing and sub aqua are other sports he enjoys, completing 27 marathons and canoeing the Caledonian Canal 3 times.

Brian has dived all around the UK coastline as well as Thailand, Cuba, Venezuela, Egypt and Mexico.

Walk Guides

THE DERBYSHIRE TOP TEN

ISBN 978-1-903568-03-3

THE COMPLETE ISLE OF WIGHT COASTAL FOOTPATH

ISBN 978-1-903568-73-6

ISLE OF WIGHT, NORTH TO SOUTH – EAST TO WEST

ISBN 978-1-903568-07-1

THE LYKE WAKE WALK GUIDE

ISBN 978-1-903568-70-5

THE LYKE WAKE WALK SOUVENIR SKETCH MAP

ISBN 978-1-903568-58-3

THE YORKSHIRE 3 PEAKS WALK

ISBN 978 1-903568-62-0

THE YORKSHIRE 3 PEAKS WALK SKETCH MAP & GUIDE

ISBN 978-1-903568-23-1

THE SCOTTISH COAST TO COAST WALK

ISBN 978-0-9526900-8-5

22 WALKS AROUND GLEN NEVIS & FORT WILLIAM

ISBN 978-1-903568-71-2

THE LANCASHIRE TRAIL

ISBN 978-1-903568-10-1

THE 1066 COUNTRY WALK

ISBN 978-1-903568-00-2

SHORT WALKS IN THE LAKE DISTRICT
ISBN 978-1-903568-20-0

JOHN O'GROATS TO LANDS END (walking)
ISBN 978-1-903568-18-7

WALK HADRIAN'S WALL
ISBN 978-1-903568-40-8

Tourist Guides

EXPLORE – FORT WILLIAM & GLEN NEVIS
ISBN 978-1-903568-25-5

TOURIST GUIDE TO VARADERO, CUBA
ISBN 978-1-903568-08-8

Cycle Guides

LANDS END TO JOHN O'GROATS (cycling)
ISBN 978-1-903568-11-8

MILLENNIUM CYCLE RIDES IN 1066 COUNTRY
ISBN 978-1-903568-04-0

Obtainable from bookshops or direct from the websites below

www.chall-pub.co.uk or **www.national3peaks.co.uk**

THE NATIONAL 3 PEAKS WALK
ISBN 978-1-903568-74-3

Fifth Edition – 2016

CHALLENGE PUBLICATIONS 7, EARLSMERE DRIVE, BARNSLEY. S71 5HH

Contents

Page

Photographs

Sketches

Three Peaks Adventure

With all our equipment together
And plans that have taken weeks
We are on our way with confidence
To tackle the National Three Peaks
You can climb them in any order
So armed with map, compass and whistle
We are heading North of the border
Travelling to the land of the thistle
The first mountain we have to conquer
To test the fitness of women and men
Is the highest climb of them all
To reach the summit of The Ben

For the route to the top of Ben Nevis
We will be taking the tourist track
This is the easiest route up there
And it won't take long to get back
We will be up and down Ben Nevis
Just see how long that it takes
Before we are back in Fort William
And heading on down to The Lakes

We are now leaving The Ben behind us
Filled with anticipation we are alike
To go and climb the next mountain
And reach the summit of Scafell Pike

For the next stage of our mission
We are leaving from Wasdale Head
It is a quick and scenic route up there
At least that is what has been said

Then with Scafell Pike now completed
And all safely back down to our wagon
We are on the final stage of our journey
Heading down to the land of the dragon
For the route to the summit of Snowdon
We will take the Pyg or the Miners' path
And our legs now tired and aching
Will think of a nice soak in a bath

Then all safely back to Pen-y-Pass
There is one thing we must do
That is give a special thank you
To a wonderful back up crew
Then thank God it was safely completed
And it was not just all a dream
But what made it all possible
Was the help of the back up team

Geoff Whittaker

Preface to the 5th Edition

The routes described in this book are written for walkers who either choose to take up the 3 peaks 24-hour challenge or to climb each peak at a more enjoyable leisurely pace. **There is no rule that says you must complete the 3 peaks in 24 hours or on a particular weekend.** Peaks can be climbed over days, weeks or years. Trying to do this in 24 hours leads to loss of enjoyment and a higher risk of accidents.

The effort required to complete the National 3 Peaks cannot be under estimated. The lack of proper sleep, food and comfort does take its toll on people of all ages, particularly those in mid-life and over, which is the average age of the long distance walker.

"One of the ultimate challenges in the United Kingdom" is how many people describe this 3 peaks walk. Ben Nevis at 1344m, Scafell Pike at 978m and Snowdon at 1085m. The challenge of climbing the 3 highest mountains in Great Britain appeals to many walkers. Included in this edition is the information for those who would like to tackle a 4th and 5th peak, Slieve Donard in Northern Ireland and Carrauntoohil in Southern Ireland. These are situated in the Mourne Mountains and in County Kerry.

This book looks at preparation, walking and driving routes to use on this 3 peaks classic walk. The inclusion of campsites and B&Bs for each area should prove a valuable help. Sketch maps have been included to use in conjunction with the relevant map. The photographs give an accurate representation of the spectacular scenery and the conditions that can be encountered on the 3 peaks.
Following the advice given in this book, which includes new and updated information, should enable all walkers to complete the National 3 Peaks Walk in a safe and competent manner.

It gives me great pleasure to present this 5th edition of my book, to help you fulfil your ambition of completing The National 3 Peaks Walk!

Brian Smailes

Introduction

The National 3 Peaks of Scotland, England and Wales consist of 26 miles of ascents and descents. Weather conditions can play a big part in deciding if you can complete the walk safely. Snow, low cloud or darkness can also be deciding factors as is your fitness level and that of your party, so you need to make careful preparations, looking at the weather forecasts and the equipment that will be used for the venture.

This walk should ideally be attempted between June-Oct, the longest day being 21st June. Many people attempt the 3 peaks in June so you may find car parks full and many other walkers around; therefore it is worth looking at other months like May, or July to September. You can of course walk it at other times of the year with caution. Mid-week is often better too with less people attempting it than on weekends and therefor more space in the car parks!

In times of snow the danger of overhangs, whiteouts and false ledges can all prove fatal if you are ill prepared (photo 11). Carry and know how to use essential equipment. In winter an ice axe and crampons are considered essential, as is experience and knowledge of winter conditions.

Photo 1. Showing the paths to 'the Ben' from the visitor centre and youth hostel

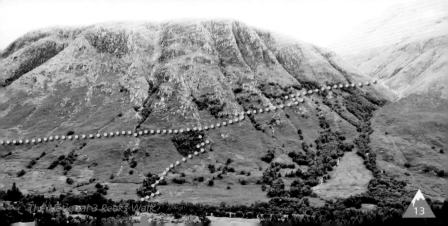

The National 3 Peaks Walk

Thousands of people walk these mountains each year; some walk only one, others all three. This guide will give the information you require to complete all 3 peaks safely and even the 5 peaks if you feel up to it!

Once you reach the summit of any of these peaks you have an awesome feeling as you look out over the mountains and probably across the low cloud in the valleys and glens. This leaves a lasting impression on any walker of accomplishment, which cannot be equaled.

There are well-defined paths leading to the summits of Ben Nevis and Snowdon. Scafell Pike is slightly different, the paths are not so well defined in places, but care in planning the ascent will help you reach the summit and return safely. At the time of writing this book, plans are being made to improve paths on Scafell Pike as well as the amenities (toilets and car parks) at Wasdale Head in particular. There are also ongoing works on the paths on Ben Nevis.

The driving route between each mountain is not complicated. Although a suitable route is shown within, drivers can obviously choose their own route which they may feel is more direct or to avoid road works or other congestion.

To assist in distinguishing each area, the headings, contents and captions are colour coded throughout:

General Information
Ben Nevis Area
Scafell Area
Snowdon Area
Optional Peaks

The Challenge

In 24 Hours

It is traditional to complete the 3 peaks challenge by starting at sea level before reaching the 3 peaks, then returning to sea level (known as "*touching the water*")

Start at Loch Linnhe, Fort William by touching the water at the main ferry terminal beside Crannog Sea Food Restaurant, GR.NN100738. This is near the main car park in Fort William on your left as you drive alongside Loch Linnhe as you pass through Fort William. Drive to the entrance to Glen Nevis and at the roundabout drive along Glen Nevis and park at the Visitor Centre GR. NN123730 (pay & display), the lay-by near Glen Nevis Youth Hostel or beside the Ben Nevis Inn. You now follow one of the two routes described to the summit of Ben Nevis.

After completing Ben Nevis, head south to either Wasdale Head or Seathwaite in the Lake District. Walk to the summit of Scafell Pike following one of the set routes. You may save some time by following the route from Seathwaite via the Corridor Route to Scafell Pike, returning to Wasdale Head car park (while the support vehicle drives round to Wasdale to collect you after your summit).

My personal preference is to start and finish at Wasdale Head, which I feel, is more straightforward, taking only 2½ hours approximately or less each way. However many people prefer the other route, which takes approximately 3½ hours to ascend and can be much tougher in parts! Currently the parking and toilet facilities at Wasdale Head are being up graded near the start.

Once you have completed Scafell Pike, head south to Wales. Park at Pen-y-pass (charge) or in Llanberis depending on which walking route you choose. Most people prefer to start from Pen-y-pass and follow either the Pyg Track or the Miners' Track. I have included these together with the Llanberis Path for those

who want a more leisurely or scenic walk to the summit.

Your 3 peaks challenge is completed when you drive to Caernarvon Castle and touch the water again at the side of the castle car park.

When attempting this challenge in 24 hours extra care should be taken because of the increased exertion required to complete in the time limit. Exhaustion can overcome you while on the mountain, and then when you stop, even for a short while, hypothermia can become a problem very quickly. There is a greater chance of completing the challenge in 24 hours by walkers being fit, accurate navigation and being properly prepared, not by trying to run up and down the peaks or speeding between them.

Due to the distance involved, driver fatigue is a major cause of accidents on this challenge, not to mention the speeding fines incurred as a result of trying to drive fast between each mountain as quickly as possible!

A new consideration is that most minibuses now have a speed limiter which will restrict your speed on the motorways so it is a lot harder to achieve the 24 hours goal! This is perhaps a good thing and will save lives and accidents by preventing speeding on the roads.

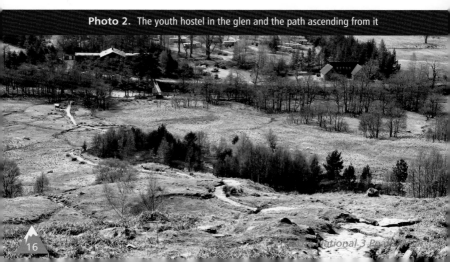

Photo 2. The youth hostel in the glen and the path ascending from it

The Leisurely Alternative

As an alternative to the 24 hour challenge, the 3 peaks can be walked on 3 individual days, not necessarily consecutive. In choosing this method you will have time to explore Fort William, Keswick, Llanberis or any other of the many tourist attractions on route.

You can of course 'walk' the peaks consecutively and this book is the ideal guide, following the routes described and road directions from one peak to the next.

Many people think this walk must be completed in 24 hours, it does not. It is probably a more rewarding experience to take your time and enjoy what is for many, a once in a lifetime event.

Photo 3. One of the two aluminium bridges on route

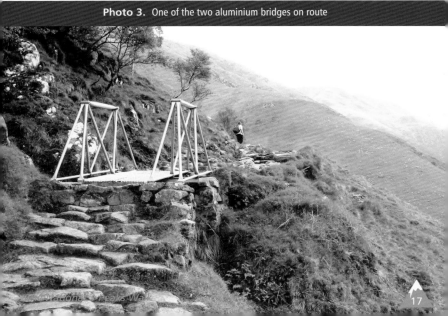

Questions You May Ask

Is the walk tough?

Generally yes, but it is a lot easier if you are fit and have put some effort in beforehand. The fitter you are, the easier it is.

Can I park in Glen Nevis Camping Park grounds or use their showers?

Definitely not, unless you are resident on the site over the period you are there. The security staff will escort you off the property.

The usual excuse is that walkers are doing the walk for charity, but the majority of people are. This does not give you a right to park or use their facilities and causes friction if you do. Park and start in Glen Nevis Visitor Centre car park or one of the other two starting points mentioned.

Are there any shops or places to buy provisions or other items in the 3 areas?

There are limited opportunities to buy provisions or other items. There is a café at Pen-y-pass (Snowdon) if open, the outdoor shop and pub at Wasdale Head and the pub and visitor centre at Glen Nevis which have normal opening times.

How can I avoid blisters and losing toenails?

Follow my recommendations described in 'Boots & Blisters' on page 29.

Are there toilets at the start of each mountain?

There are toilets at Glen Nevis Visitor Centre, Wasdale Head and Pen-y-pass car park. There are also toilets on the summit of Snowdon in the café (if open).

Can I set up a checkpoint to supply our group with food etc. in Pen-y-pass car park?

No, the car park is usually full, especially on weekends and because of walkers leaving litter and creating blockages in the car park, group catering is not permitted.

How can I stop my leg muscles from seizing up?

I find the best way is to get some ankle weights and wear them around the house etc. Start with 15 minutes and build up gradually to wearing them for 7 hours each day for a few weeks before you go. Doing this will tone up those muscles. Many people wear light shoes/trainers on their feet then suddenly put on a pair of heavy boots and expect to walk up the three highest mountains, they cannot!

Where can I get souvenir badges, T-shirts, certificates, photo CD or film DVD of our challenge?

Look no further. Souvenirs can be purchased from the address or website near the back of the book. We have a large range of quality souvenirs. Pay-pal and debit card via pay pal are accepted. Quality certificates can be purchased for all 3 peaks individually or a combined 3 peaks certificate (most popular) or even a 5 peaks one!

Can we walk during the night on any of the 3 peaks?

Yes you can but if you start during the night you must have regard for the local residents who will probably be asleep. Do not sound horns, rev engines or make lots of noise but park then start your walk quietly.

I have forgotten an essential piece of equipment or clothing, where can I buy a replacement?

You can buy equipment during normal opening hours at the following:

Fort William: There are several good quality outdoor shops and a vast range of outdoor equipment to purchase.

Wasdale: There is the Barn Door Shop at Wasdale Head.

Keswick: is the place for equipment if you are starting the walk from Seathwaite.

Snowdon: there are outdoor shops in Llanberis and when passing through Betws-y-Coed.

Preparation

Most people who tackle this challenge already know what to wear and have some experience of preparation. This next section is not aimed at those people but to those who are new to walking and may not know about clothing and the preparations to take when doing the 3 peaks challenge.

This walk is not considered long compared with many other walks. Maximum distance on one mountain is 10 miles, even so if you are not prepared it could lead to problems. When preparing you need to consider the following:

- **Fitness**
- **Equipment**
- **Familiarisation**
- **Logistics**
- **Food**

Fitness

The main problems on this walk are the steep, rugged ascents and descents especially on Ben Nevis and Scafell Pike. Because of this there is a lot of pressure on the leg muscles, knees and Achilles tendon. This pressure will considerably increase if you are attempting to climb all 3 peaks consecutively.

Exercise should be taken to build up stamina weeks ahead, i.e. walking, jogging, cycling and swimming all help to improve fitness.

Walk at an even pace, which helps to conserve energy and maintain body heat and slow release of energy. This steady pace will usually help you to overcome difficult sections without becoming exhausted. Some walkers set off at a brisk pace and often become exhausted soon afterwards. The combination of exhaustion and loss of energy can hasten the onset of hypothermia.

Food

Food consumed both before you start and while walking can affect your body heat and energy level. High-energy food such as bananas, rice, pasta, potato and wholemeal bread are all carbohydrate rich and of benefit. Eating little and often and drinking frequently is the best advice. Doing this will provide a sustained supply of energy throughout your walk.

Familiarisation

Study your map and familiarize yourself with the route and various landmarks, where possible visit the areas before you walk. An escape route should be planned in the event of bad weather or an emergency, (see bad visibility descents).

Note where the mountain rescue posts are situated, along with the nearest telephones and areas where shelter can be provided. Look for danger areas e.g. gullies, ledges etc.

Equipment

It never ceases to surprise me how many people ascend the mountains in inappropriate clothing and footwear. People walk in jeans and T-shirts without any protection from the biting cold wind and possibly rain on the summit. Trainers are often worn to walk over the snow on Ben Nevis and the wet and muddy sections on all 3 peaks. I have witnessed a lady ascending Ben Nevis in stiletto heels, jeans and T-shirt!

When considering equipment and clothing for this walk, you must remember that it may be calm, still, and what seems like a nice day at the base of the mountain but nearing the summit of any mountain it can be cold and very windy with low cloud. Often it is the wind chill factor that causes problems for walkers. With this in mind, the following suggested list of items should help you to both complete the walk and stay warm, dry and hopefully injury free.

Boots

These are an essential item on this walk. A good fitting pair of walking boots can make the difference between success or failure on any walk. Ankle protection is important especially on the peaks of Ben Nevis and Scafell Pike, where large stones and scree can inflict damage very easily.

Before buying boots always try them on wearing the socks you will use with them. The boots should not be too tight as to cramp your toes, likewise not too slack that your feet move around inside. It is important to 'wear the boots in' meaning wear them several times before the event.

Socks

These should keep the feet warm and cushion them from any knocks and constant pounding. You can usually buy short, medium or long and thick/thin depending on preference. Take several pairs and some foot powder to keep them dry and fresh. A clean pair of socks gives feet a new lease of life.

Trousers

Should be loose fitting and ideally made of cotton or a fleece type of material. Cotton trousers will be light to wear, keep you warm and most importantly will dry quickly when wet.

Jeans are not suitable for walking as they take a long time to dry when wet and become very heavy. They can also chafe the skin and draw the body heat, so giving you hypothermia, and their insulating property is very low. Jeans are a definite **NO!**

Hat/gloves

Much of the body's heat is lost through the head, so hat and gloves are strongly recommended.

Jacket/waterproof trousers

There is a vast assortment of jackets available for this type of venture from fleece to coated and breathable materials. If there is a hood attached this will give good protection around the head. Whichever jacket you are buying, ensure it is waterproof and not just shower proof (front cover).

Waterproof trousers are necessary to keep you dry on those wet days. Do not wear water/wind proofs any longer than necessary as quite often condensation builds up inside.

Breathable Clothing

Clothing which is classed as breathable is only breathable as long as the pores of the item are not blocked, e.g. when wet!

Rucksack

This should be large enough to hold all your personal and safety equipment. Put a liner inside to keep your clothes and other items dry in very wet conditions. Use the rucksack pockets to put small or frequently needed items in, i.e. water bottle, map, food etc.

Clothing

Clothing should be built up in layers where warm air can be trapped between each layer. Three thin tops or T-shirts are more effective than one thick one. If you are hot you can easily take a layer off.

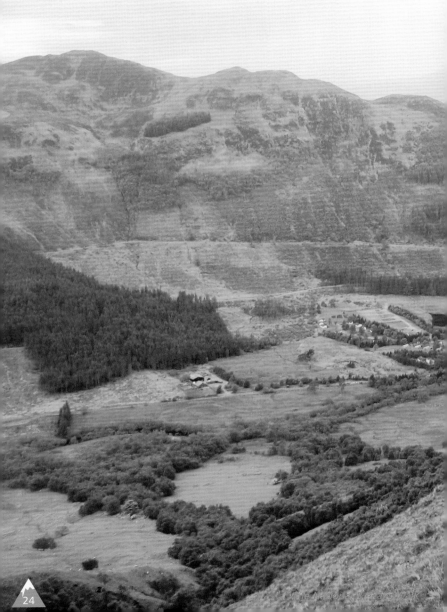

Photo 4. The path before the halfway point, with good views of Glen Nevis and the youth hostel

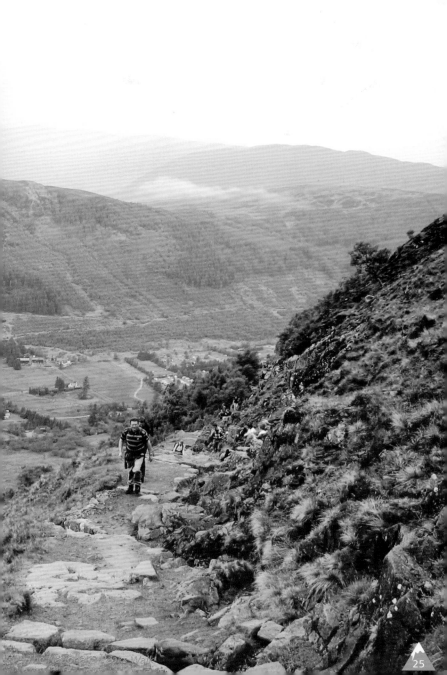

Emergency Equipment

Torch

Each person should carry one; take spare batteries and a bulb. Check it works before ascending each mountain.

Pencil & Notebook

It may be necessary to take notes on route especially in an emergency when positions, names, injuries etc. should be written and passed onto the emergency services.

Whistle

Each person should carry a plastic whistle (metal ones can freeze in the cold) and they should also be familiar with the 'S.O.S.' signal to alert others in times of emergency.

Survival Bag

Designed for a walker to get inside to protect them from the harsh environment and to preserve body heat. It is a piece of safety equipment that may never be used but should always be carried.

G.P.S.

This is a relatively modern aid and it is advisable to take but ensure you know how to use it and can find your position from it on a map, otherwise it is a waste of time taking it.

The National 3 Peaks Walk

Equipment Checklist

- ☐ Compass and guide book
- ☐ Walking boots
- ☐ Walking socks (including 2 spare pairs)
- ☐ Walking trousers (no jeans)
- ☐ Warm upper body clothing (in layers)
- ☐ Spare clothing
- ☐ Gloves, hat
- ☐ Torch with spare bulb and batteries
- ☐ Whistle
- ☐ Note paper and pencil
- ☐ Toilet paper
- ☐ Survival bag
- ☐ Basic first aid kit including plasters and Vaseline
- ☐ Fleece/waterproof fabric outer jacket/cagoule
- ☐ Over trousers, waterproof
- ☐ Day rucksack
- ☐ Food/drinks/snack items
- ☐ Camera - optional
- ☐ Maps of the three relevant areas.
- ☐ Gaiters – optional
- ☐ Watch
- ☐ G.P.S. - optional

Other items you may wish to take

Sun cream, midge repellent, mobile phone and sun hat
Use this as a checklist before you leave home.
Mobile phone reception should not be relied upon throughout
this 3 peaks walk. There are some areas with good reception,
but some with none!

The National 3 Peaks Walk

The Body

Should be kept warm.
Build clothes up in layers with wind/waterproofs on top.

Rucksack
Containing food, drinks, first aid,
clothing, map and compass.

The Head
Should be kept warm, more
heat is lost from the head than
anywhere else.

Main Body Core
Temperature must be
maintained.

Hands
Should be kept warm
with gloves.

Legs
It is important not to
wear jeans.

Ankles
Should be protected by wearing
boots. These will help stop you
going over on your ankle and
strengthen it.

Feet
Should be kept well cushioned
and dry if possible. Good fitting
boots will help prevent blisters.

Boots & Blisters

Two of the most important things on this walk are your feet and boots. If your feet hurt or you suffer with bad blisters, then you may not complete the walk. Boots need to be big enough to fit comfortably but not too big so your feet move around inside whilst walking. Remember to fit the boots with the socks you will be wearing, when buying.

Sprinkle a liberal quantity of foot powder on your feet and in the socks. Put foot powder into your boots and on the outside of your socks, then put your boots on making sure your feet fit snugly into them. This method has helped many people to keep their feet not only dry and fresh throughout but more importantly blister free after 25 miles.

Change socks as often as you feel you need to. Doing this will refresh your feet and provide cushioning. If you feel any warm spots on your feet or toes, do not wait until a blister has formed, it is too late then. Change socks, sprinkle foot powder on or put a plaster on.
I recommend you use a clean pair of socks for each mountain and always carry a spare pair with you.

Remember to cut your toenails short before you leave home so you don't get any undue pressure on your toes whilst walking or descending the mountains, which will result in black and painful toenails or the loss of them!

First Aid

Knowledge of basic first aid would be helpful on any walk. To be able to bandage cracked ribs, put a sling on or dress a wound can be vital in times of accidents, especially on the higher crags, when hypothermia can set in.

In any accident or emergency situation the ability to reassure the casualty and comfort them is very important, do not move the casualty if the accident is of a possible serious nature e.g. a back or head injury. Keep the casualty warm and reassured then send for help. Someone should stay with the injured person. If the injury is not of a serious nature the injured person should, if and when possible, be removed from danger.

The possibility of shock or delayed shock can present further problems for the casualty, so reassurance and company is vital. The majority of accidents happen on the return or second half of the journey, probably due to fatigue, cold or complacency.

Be aware and alert throughout the walk to possible dangers.

Common Types of Injuries
- Cuts and grazes
- Broken arms/legs
- Blisters
- Cracked ribs
- Hypothermia
- Head injuries
- Sprained ankle/wrist
- Gashed shins
- Toe nails dropping off
 – cut before you go!

Some of the above can prove fatal, especially on an exposed area of the mountain or in times of panic, low cloud or adverse conditions.

Individual First Aid Kit
- Adhesive dressing
- Waterproof container
- Scissors
- Triangular bandage
- Sterile dressing
- Micropore tape
- Bandage
- Crepe bandages
- Sun cream
- Safety pins
- Gauze/lint
- Insect repellent

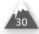

The National 3 Peaks Walk

Hypothermia

Hypothermia is caused when the body core temperature falls below 35ºC. If a walker is not properly prepared for the conditions or the clothing worn is not satisfactory, then a combination of the cold, wet, exhaustion and the wind chill factor can cause hypothermia.

When you stop walking for a while, you quickly get cold. To combat this, put another layer on, zip up and put gloves and hat on.

The Signs and Symptoms in Descending Order:

• Shivering

• Cold, pale and dry skin

• Low body temperature

• Irrational behavior

• A gradual slip into unconsciousness

• Pulse and respiratory rate slow

• Difficulty in detecting breathing and pulse when unconscious

• Death

Ways of Preventing Hypothermia

• Build up body clothing in thin layers, adding on or taking off as necessary

• Have suitable wind/ waterproofs with you

• Take some food/hot drink or boiled sweets, which produce energy and heat during digestion

• Wear a balaclava/woolly hat to insulate the head, and some gloves

• Shelter out of the wind

• Take a survival bag and if conditions dictate, use it

In any type of emergency/ accident situation it is always advisable to descend off the higher ground as soon as possible especially in low cloud, snow or other bad conditions. The temperature difference between a valley and the high ground can be several degrees.

Treatment for Hypothermia

- Provide extra clothing and shelter from the elements
- Bodily warmth of others helps in a gradual warming
- If well enough come down into a warmer sheltered area
- Give hot drinks if conscious
- Give chocolate or sweets if the patient can still take food
- The casualty should be placed so that the head is slightly lower than the body
- Reassure the casualty and continue to monitor then and keep them warm

DO NOT *rub the skin or use a hot water bottle as this can cause a surge of blood from the central body core to the surface, this could prove fatal.*

Alcohol should not be consumed on any walk and should not be given to anyone who has hypothermia. The body temperature will be lowered as well as giving a false sense of security.

Photo 5. Crossing the waterfall

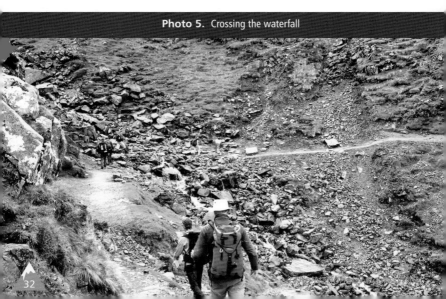

Top Tips for Completing the 3 Peaks

- Prepare and train before the walk. Those who do some training and preparation usually succeed those who do not, may not succeed.

- Take and wear the right walking clothing. This includes boots, waterproof jacket and trousers (see equipment list). No jeans, T-shirt or high heels!

- Carry at least two spare pairs of walking socks and change them if you need to. This will help to revive your feet and give them new life.

- Eat little and often. Doing this will give a constant supply and release of energy to the body.

- Drink regularly. If the body becomes dehydrated, you will lose energy fast.

- Carry a map and compass with you and know how to use them.

- Ensure you have emergency and first aid items with you including torch, whistle, survival bag, first aid kit and blister plasters.

- Cut toenails short before you leave home.

- If you feel a blister forming or a warm spot on your feet, do not wait until the blister has formed before you do something about it. Stop and put a plaster on before it is too late. Look after your feet and they will look after you!

- Carry only items you need for ascending each mountain and no more. Remember you have to walk up and down the 3 highest mountains in the UK. Grams turn into kilograms, ounces into pounds every time you put something more into your rucksack.

- If walking at night, ensure you carry a torch, spare batteries and bulb. Do not be left in darkness.

- On reaching the summit, only stay as long as necessary. If you feel cold then leave the summit and descend to lower ground where it is usually warmer and more sheltered.

Mountain Safety

Details of your route should be left with your support team or someone who can monitor your progress and most importantly alert the rescue services if you are overdue. Because you plan a route it does not mean you have to use it. It is better to cancel if there is a problem than to risk lives ascending a mountain in atrocious conditions or if the team are ill prepared.

Many people do not realize that a calm sunny day in the valley can mean low cloud and gale force winds on the summit, add to this the wind chill factor and a walker badly prepared has got problems. Bad weather can sweep in quickly. It is usually warmer and better weather on lower ground, so if cold but uninjured, make your way to the lower ground if you encounter problems while walking.

Only walk routes which are within the capability of your party. One of the most common problems that can lead to accidents is walkers becoming separated from each other. There should be a party leader and that person should ensure the group walks at a sensible pace and together. This is usually the speed of the slowest walker. Each person should carry a map and compass and a route card and they should all have been involved in drawing up the route beforehand. Copy and use the sample route card inside the back cover.

If you are delayed e.g. you have descended into the wrong valley, inform your base or the police as quickly as possible to avoid the mountain rescue team from being called out unnecessarily.

All walkers should be familiar with the **INTERNATIONAL DISTRESS SIGNAL:**

- 6 long blasts on whistle
- 6 shouts or waves of handkerchief
- 6 flashes of torch in succession

All followed by a pause of one minute, then repeated.
A red flare is a distress signal.

Conservation & the Country Code

- Be safe, plan ahead and take notice of relevant signs

- Leave gates and property as you find them

- Protect plants and animals and take your litter home including any glass

- Keep dogs under close control

- Consider local residents and other people, especially if you are passing through villages at night on route. Keep noise to a minimum and don't sound horns

- Guard against all risk of fire

- Be conscious of footpath erosion at all times

- Don't touch livestock, machinery or crops

- Use gates and stiles to cross walls and fences

- Leave nothing but footprints, take nothing but photographs

- Don't drop litter

- If you need to urinate, do so at least 30m from streams and burns

- Do not use any emergency shelters as a toilet or to sleep in unless in an emergency

- Do not build cairns or pile up stones yourself on any mountain

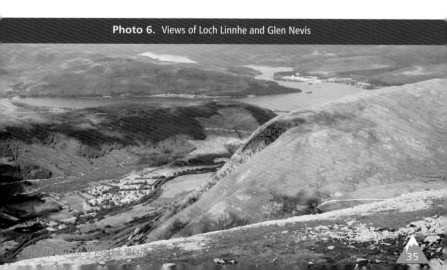

Photo 6. Views of Loch Linnhe and Glen Nevis

The conservation aspect:

1. Will the walkers or support crew clear away all the litter at each base before they leave and dispose of it in the appropriate place.

2. Review the event afterwards to assess the benefits, impacts and lessons learned for future event planning and implementation.

3. Will the group share this knowledge with others?

4. Will the group consider a donation for path restoration or similar project in any of the 3 areas?

5. Will the group consider carbon offsetting or minimizing the impact on the environment of their trip by planting trees or making a donation to woodland charities?

Photo 7. Walkers on the higher slopes

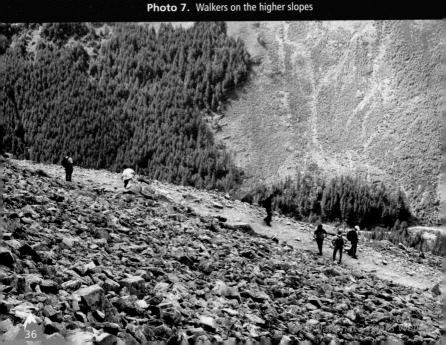

Weather Forecasts

The importance of checking the weather reports before you ascend each peak can be vital to the success or failure of your team.

Notices displaying the current weather patterns on the peaks of Ben Nevis and Snowdon are usually near the start of the routes described. It is advisable to listen to the forecast on local radio if possible for the area you are in.

Calm, still weather in the valley or glen can turn to gale force winds on the peaks. Check your forecast before you ascend; are you liable to encounter low cloud, heavy rain, snow or scorching sun on your journey? Usually the forecast can help in deciding what time to start walking and what type and how much extra clothing you need to take with you and whether you need sun cream, insect repellent and extra fluid.

When walking in mountainous country you can often tell if there is, or will be a deterioration in the weather by the onset of low cloud around the peaks. Keep checking your present position and look in the direction you are intending to go as far as you can see. Take a bearing with your compass then follow that bearing through the cloud to your intended destination using both map and compass where necessary. Never be caught unawares, when you reach that spot look again as far as you can see, take your bearing again then proceed as before.

On the National 3 Peaks snow can present problems at certain times of the year. 'Driving' snow creates whiteout conditions. Where conditions are very bad, then only those with a great amount of experience should be on the mountains. In virtually every type of situation like this it may be better to abandon the attempt than to risk lives on dangerous peaks.

Navigation

The ability to find your way from one place to another especially in bad weather is something that needs to be learned. Although we may have a sixth sense or sense of direction, when the cloud is low, even the best of us can get lost quickly.

Before embarking on your 3 peaks walk you should have an understanding of the basic principles of map reading and compass use. It is not intended that this walking guide should give you the information on how to use navigational equipment but only to point out the need for walkers to be prepared before venturing out especially in bad visibility.

Learning how to read the contours of a map can be of benefit and being able to recognise landmarks seen on the map. Combined with this, basic course plotting and magnetic variation should at least help you to come down from the mountain in any problem situation.

There is a need to practice your navigation skills until you feel confident enough to venture

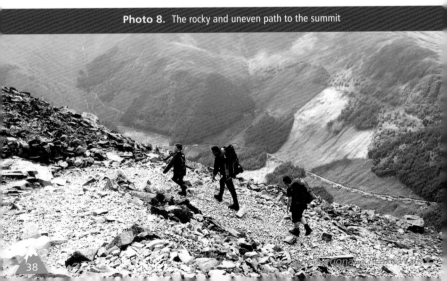

Photo 8. The rocky and uneven path to the summit

onto the hills and moorland. Most people know the general principles of pilotage where the sun rises in the east and sets in the west, you can therefore get some idea on a clear day as to which general direction you are walking in, however you would not know if you were heading into danger e.g. steep gullies, cliffs or overhangs.

There are many books that deal with map and compass training and courses are available to those that seek them. Use and learn as much as possible about map and compass work.

Over recent years the use of hand held GPS systems has become much more widespread. They are very useful for pinpointing your position, particularly in bad weather. I strongly recommend them. If taking a G.P.S. on your 3 peaks venture, take some spare batteries.

Photo 9. Near the summit now with good views of Loch Linnhe

Area Postcodes of Each Mountain Start Point

Use these postcodes in your vehicle sat nav to take you directly to the start of each mountain.

Ben Nevis

Glen Nevis Visitor Centre - **PH33 6PF**

Lay-by beside Glen Nevis Youth Hostel - **PH33 6SY**

Parking area outside the Ben Nevis Inn - **PH33 6TE**

Scafell Pike

Wasdale Head car park - **CA20 1EX**

Seathwaite parking area - **CA12 5XJ**

Snowdon

Pen-y-pass car park - **LL55 4NY**

Llanberis car park - **LL55 4TY**

Photo 10. On the summit at sunrise with the emergency shelter in the distance

Grid References

You may find it necessary at some time to either find a place from a given grid reference or to make a grid reference from a place on a map.

All maps have grid lines running north to south and east to west. These are called 'Eastings' and 'Northings' and these lines have numbers on them. They can be further split into tenths, the numbers range from 00 to 99.

Grid references are normally given in six figures. The first three figures indicate how far to the east the place is.
The second three figures indicate how far to the north the place is.

To make a grid reference look from left to right on a map. Read the numbers going from left to right, write the numbers for the grid line to the left of your position, estimate the tenths to your position and write that number down to make 3 numbers.

Now look up the grid line on your map and write the 2 numbers from just below your position. Repeat the second sequence as above. You should now have 6 numbers usually written as GR. 647556

In using this method you should be able to pinpoint your target or position quite accurately on a 1:25000 scale map. Before you ascend the peaks you need to practice until you can both find grid reference points on a map and create a grid reference from a given position (e.g. the grid reference for Ben Nevis at the 'trig' point, using 6 figures on O.S. Explorer map 392 Ben Nevis & Fort William is 167713.)

Ben Nevis Routes

Visitors Centre Start

P

P

Ben Nevis Inn Start

Lochan Meall An T-suidhe

Paths converge

Youth Hostel Start

The National 3 Peaks Walk

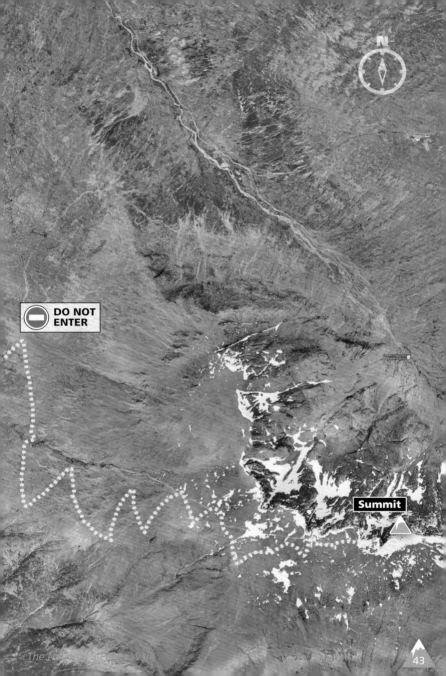

DO NOT
ENTER

Summit

Map of West of Scotland

Fort William can be freely accessed from throughout the country. There are roads and rail links to Fort William as well as airports in Inverness and Glasgow (see useful telephone numbers in back of book). Fort William is situated at the southern end of the Great Glen.

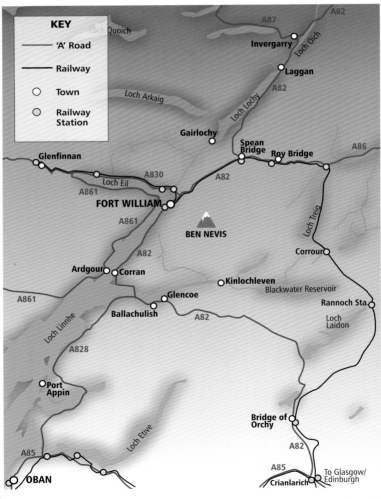

KEY

— 'A' Road

▬ Railway

○ Town

○ Railway Station

Loch Quoich

A87

A82

Invergarry

Loch Oich

Laggan

Loch Arkaig

A82

Loch Lochy

Gairlochy

Spean Bridge

Roy Bridge

A86

Glenfinnan

A830

A82

Loch Eil

A861

FORT WILLIAM

A861

BEN NEVIS

Loch Treig

Corrour

A82

Ardgour

Corran

Kinlochleven

Blackwater Reservoir

A861

Glencoe

Rannoch Sta.

Ballachulish

A82

Loch Laidon

Loch Linnhe

A828

Port Appin

Bridge of Orchy

Loch Etive

A82

A85

A85

To Glasgow/ Edinburgh

OBAN

Crianlarich

The National 3 Peaks Walk

Fort William & Glen Nevis Area

Fort William is the main town near the foothills of Ben Nevis. It also represents the start or end of the Caledonian Canal, which runs to Inverness on the east coast. The West Highland Way ends here and The Great Glen Way starts here.

Within the area there are many outdoor activity centres, which cover all manner of water sports and land based activities. Fort William Tourist Information Centre provides interesting displays of local attractions as well as general information about the area.

The Glen Nevis Visitor Centre provides information, especially on Ben Nevis and the Glen Nevis area.

There are many mountains in the area to walk, whisky distilleries to visit, cable cars and cruises to venture on and restaurants around Fort William offering a variety of good food.

Many of the buildings are stone built and the town is clean and pleasant. The local people are keen to welcome visitors and there are numerous hostelries in which to sample local ale. A visit to the town is not to be missed. There are several outdoor shops selling maps, compasses and most outdoor equipment.

Loch Linnhe borders Fort William and provides fishing and sailing for those who enjoy alternative sports and hobbies. Those walkers who have time to relax after climbing Ben Nevis will find the area around Fort William very pleasant and picturesque. A wide range of shops cater for all tastes in local food and souvenirs. Over recent years the area has become a film set with films such as Braveheart, Harry Potter and Highlander being filmed here. Travelling to Fort William by car will provide some of the best views anywhere in the U.K. particularly travelling through Glen Coe. A rail and bus link will also transport you there from throughout the British Isles. Take a camera to give you some lasting memories.

The path to the summit of Ben Nevis (see Ben Nevis sketch map, page 48) was originally built as a pony track to service the observatory and the hotel on the summit, which are now in ruins. The observatory was operational between 1883-1904. During the summers of 1881-82, Clement Wragge climbed to the summit each day to record daily temperatures. The average temperature between 1884 to 1903 was only 0.3°C.

A 4-bedroom hotel was built close to the weather station by a Mr. White and run by two ladies during the summer months. It did not stay open for many years however, and the ruins can be seen on the summit today.

Surprisingly there have been a number of cars that have actually driven to the summit. In 1911, Henry Alexander was the first man to the top in a 20 horsepower Ford model T. Since then there have been several cars that have reached the summit.

The fastest was 7 hours 23 minutes in 1928 by George Simpson in an Austin 7.

Dudley Grierson from London ascended 'the Ben' on a motorbike in 1901. Since then there have been various ascents using horse and carts, beds, wheelbarrows and walkers carrying items such as barrels of beer and pedal organs!

The highest war memorial in Britain is situated on this summit (photo 12). The views from here are breathtaking in all directions.

The tourist path is used for the Ben Nevis annual race, which takes place on the first Saturday in September. It takes around 2 hours for the fittest to complete the race from the start to the summit and back. The Lochaber mountain rescue team supervise this.

The 'Ben Path' starts out relatively easy but becomes increasingly rocky, arduous and exposed. Many people do not

appreciate their level of fitness and how difficult they may find it. Plan to set off early in the morning to avoid returning in the dark.

The majority of accidents happen on the return journey which can be just as tiring as the ascent. Take this into consideration when planning your ascent.

The road along Glen Nevis runs for approximately 7 miles. You will find the Visitor Centre, the Glen Nevis Caravan & Camping Park and the Glen Nevis Youth Hostel along this road.

The mountains tower on both sides of the glen where the road eventually stops at a car park at the far end.

Photo 11. One of the summits many dangerous gullies where snow often overhangs

Ben Nevis

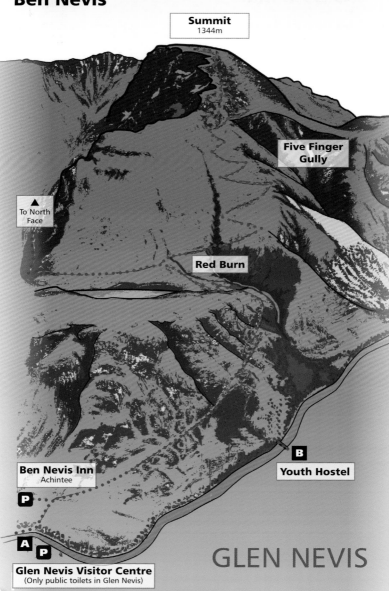

Summit
1344m

Five Finger Gully

▲
To North Face

Red Burn

Ben Nevis Inn
Achintee

P

B
Youth Hostel

A
P

Glen Nevis Visitor Centre
(Only public toilets in Glen Nevis)

GLEN NEVIS

The National 3 Peaks Walk

Plants & Animals on Ben Nevis

The lower slopes of 'the Ben' are covered in grass, small bushes and heathland and it is here that voles and small lizards can be seen. Several birds such as wheatears, stone chat and ring ouzel are seen as well as the meadow pipit in summer. On the upper slopes of the mountain, the ptarmigan, a more hardy bird may be seen.

Looking at the plants on Ben Nevis, bog plants like butterwort and sundew as well as mosses and lichens grow on the lower slopes. Some alpine plants grow on the upper slopes like the yellow mountain, golden saxifrage and lady's mantle. As you ascend it becomes more hostile and is home to lichens and mosses as most of the plant life diminishes.

Deer have been seen on Ben Nevis, particularly on the lower slopes. Stoats, weasels and even a badger have also been seen on 'the Ben'.

In summer if you look carefully and are observant, there are many plants, animals and birds all around us when we climb Ben Nevis, but in winter when the tourists diminish, the plants and the birds who can weather the harsh environment are left to themselves until the spring comes along and life returns to the mountain.

Photo 12. The cairn of remembrance on the summit of Ben Nevis

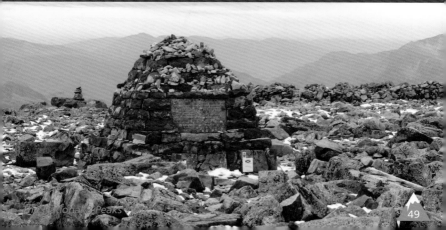

Ben Nevis Grid References

As many people have GPS systems, below is a list of GPS grid references so you can pre-enter the co-ordinates before leaving home.

The route starts from the Visitor Centre in Glen Nevis to the summit walking on the popular mountain track. On your way up the path, when you reach the area near the Lochan, at GR.147724, ensure you follow the mountain track (tourist path) and not the climbers path to the north face.

The route is both undulating and winding so allowance must be made for this when walking and using the GPS in low visibility.

Map to use is O.S. Explorer No.392 Ben Nevis & Fort William.

Start Glen Nevis Visitor Centre

GR. 123730

GR. 123732

GR. 126728

GR. 131723

GR. 140718

GR. 147724 Lochan (turn right on path)

GR. 147718

GR. 147715

GR. 149717

GR. 151713

GR. 155715

GR. 157715

GR. 161713

GR. 166712

GR. 167713 'Trig' Point

Walking Routes - Ben Nevis

There are 2 main starting points to climb Ben Nevis:

• Glen Nevis Visitor Centre (recommended).

• The Youth Hostel

Start A - Glen Nevis Visitor Centre (Recommended)

Many people start by touching the water at sea level at Fort William, then touching it again to finish at Caernarfon.

We start by touching the water of Loch Linnhe beside Crannog Sea Food Restaurant, near the main car park in Fort William. It is also the main ferry terminal. Take the Inverness road then at the sign to Glen Nevis at the Nevis Bridge roundabout go straight across. From the roundabout it is 1.2 miles to the Glen Nevis Visitor Centre. Park in the car park here (pay & display). Near the car park is a pedestrian suspension bridge crossing the River Nevis. A sign points to 'Ben Path'. Follow this passing a guesthouse. The visitor centre is now off on your right and the Ben Nevis Inn is off to your left.

A sign states 'Ben Path', ascend for 150m following the main path and signs. As you ascend you have a good view of Glen Nevis Caravan & Camping Park to your right. The path becomes stony, uneven and ascends steeply (photo1). Continue on this path, which eventually joins path 'B' further along the glen.

Start B - Youth Hostel

Start by touching the water as described in Start A (page 51). Take the Inverness road, a sign at the Nevis Bridge roundabout points across to Glen Nevis. Pass Glen Nevis Caravan and Camping Park on your right and park opposite the youth hostel nearby the suspension bridge 370m further along the road (limited parking). This is 2.1 miles from the roundabout. Do not park in Glen Nevis Caravan Park or use their facilities unless you are staying there.

Your ascent of Ben Nevis begins here. Immediately opposite the youth hostel there is a footbridge crossing the river, cross it, then cross some steps over a fence. A sign here usually displays a description of Ben Nevis with the current weather forecast and other information.

Continue steeply up a winding, stony path (photo 2), a man made path develops forming steps as you ascend. Part way up, the path joins path 'A'.

Both paths converge and you cross over a wooden platform bridge. You are now on the main path ascending Ben Nevis, which is known as 'The tourist track'. The path is very stony and more uneven on this section due to some erosion. Approximately 80m further up is a seat on a bend in the path. You come to a metal bridge and this point affords good views of Glen Nevis.

Cross over a small burn

running down a gully, the path here is hard mud, interspersed with stones as it winds up the hillside. The path turns sharp left then right, followed by steps up a steep rock outcrop. The sound of a fast flowing burn running down another gully can be heard. A natural spring escapes from the hillside so the path is usually wet here.

A stone outcrop and another metal bridge (photo 3) with a waterfall beneath is crossed. The path then ascends steeply between the two mountains with Red Burn on your right. While ascending the side of the mountain burn you come to a sign saying Conservation Area. The path twists left and right as you approach the lochan halfway up the mountain. The path levels out a little here as you walk on a recently made stone path. The area is open with a large expanse of grass. Lochan Meall an t-Suidhe is on the left.

It is important to note that the path going straight on leads to the area that the climbers use.

Follow the constructed path as it turns immediately right and uphill again by a short section of wall. There are some piles of stones at the bend in the path. From this point to near the summit there has been a significant amount of work undertaken to repair the path and steps created to improve access. Work is ongoing each year.

There are good views across the mountains as you continue to ascend (photo 4). To your right further on there are some steep drops off to your

right. Cross another burn where walkers often stop for refreshment (photo 5). Approaching the upper slopes, you can look down the glen to the youth hostel (photo 6). Stay on the main path towards the summit.

The final zigzag (photos 7 & 8) ascent is very rocky and uneven, with loose stone and scree. The top of the five finger gully has a deceptive gentle slope (see sketch), which quickly leads to dangerous cliffs. Pay attention and ensure you are heading in the right direction. As you approach the gully the route bends sharp right on the scree path. Near the summit the path levels out, with a lot of small stone (photo 9). Quite often, up to mid-summer, the area is covered in snow.

You may see piles of stones or man-made cairns on your ascent as you proceed if there is no snow. These are to help walkers keep to the designated route. Follow your path carefully and if there is snow, it is

Photo 13. The summit showing the 'trig' point and emergency shelter

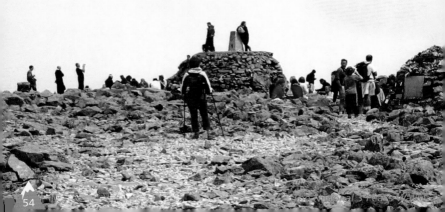

important to stay on the path if possible.

Approaching the summit you may find a sudden decrease in temperature so it is time to zip up jackets and pull up hoods and put gloves on if you have not done so already. Maintaining your body temperature is essential so do not get cold and suffer from hypothermia, wrap up!

Immediately before the summit take extreme care of the sheer drops over the edge of the mountain, down the infamous Gardyloo Gully, Tower Gully and No.2 Gully. Stay on the path watching for snow overhangs on the gullys, which can be deceiving (photos 10 & 11). The gully just before the flat plateau summit is close to the path (photo 11), so bear right on the worn path, heading for the ruins of the observatory.

On reaching the summit you have excellent views in all directions (cloud permitting). There is a triangulation pillar,

number S1595 and emergency shelter (photo 13). A cross with a cairn and plaque states it is Britain's highest War Memorial (photo 12). It is the Fort William Dudley/ Worcestershire Cairn of Remembrance.

After resting for a short time on the summit you may find the cold penetrating the body. This is now the time to start your descent to warmer and more sheltered areas. Retrace your steps down the mountain ensuring you return on the correct path.

In times of bad visibility follow the bearings and directions given in the chapter on bad visibility descents. N.B. Ben Nevis should be treated with respect at all times, at over 4,000ft the weather on top can be very different to what you expect e.g. deep snow in May with thick cloud and ice. It is strongly recommended that you carry a good quality map of Ben Nevis with bad visibility routes in scales of 1:10,000 or better. This is for your safety and that of others.

Driving Route To Scafell Pike

	Road		Destination
Leave Fort William	**A82**	To	North Ballachulish
at North Ballachulish	**A82**		Crianlarich via Rannoch Moor
at Crainlarich	**A82**		Tarbet
at Tarbet	**A82**		Dumbarton
at Dumbarton	**A82**		Erskine Bridge
at Erskine Toll Bridge	**M898**		Glasgow
at Bridge (south)	**M8**	To	M74
on M74	**M74**		Abington
at Abington	**A74M**		Gretna
at Gretna	**M74/M6**		Carlisle
*at Carlisle	**M6**		Penrith
at Penrith	**A66**		Keswick
at Keswick	**B5289**		Grange
at Grange	**B5289**		Seatoller
at Seatoller	**Minor**		Seathwaite

Park alongside the narrow road leading up to the farm at Seathwaite. Do not block the road!

Leave Walkers - Drive to Wasdale Head for pick-up - (Optional)

	Road	Destination
at Seathwaite	**B5289**	Crummock Water
at Crummock Water	**B5289**	Brackenthwaite
at Brackenthwaite	**Minor**	Mockerkin Tarn A5086
at Mockerkin Tarn	**A5086**	Egremont
at Egremont	**A595**	Gosforth
at Gosforth	**Minor**	Wellington
at Wellington	**Minor**	Wastwater
at Wastwater	**Minor**	Wasdale Head

Route from Carlisle direct to Wastwater - Recommended

	Road	Destination
*at Carlisle	**A595**	Cockermouth
near Cockermouth	**A5086**	Egremont
at Egremont	**A595**	Gosforth

At Gosforth turn left onto minor roads to Wasdale Head. Park in the new car park being constructed during 2015/6 (pay & display) or on the village green (if permitted), just past the northern end of Wastwater or turn right over the bridge into the National Trust car park at the side of the campsite (pay & display).

The National 3 Peaks Walk

Scafell Pike Routes

Burnthwaite B&B

Wasdale Head Inn

Wasdale Head Start

National
Trust Start

Mosdale Beck

Brown Tongue
(Cross Lingmell Gill)

Campsite

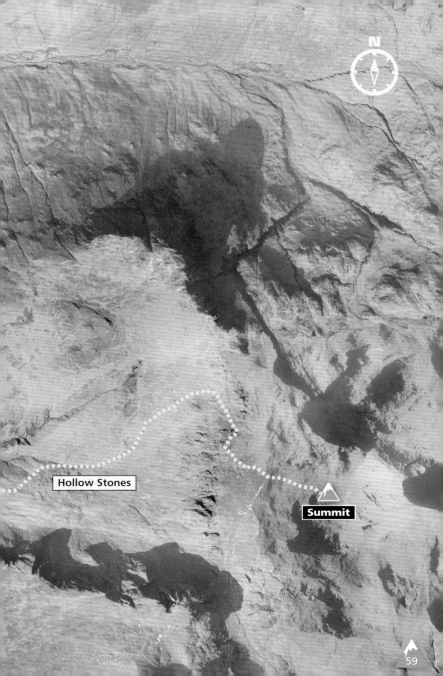

Hollow Stones

Summit

Scafell Area

Wastwater on the southwestern side of the Lake District and Derwent Water to the north borders Scafell Pike. The nearest main towns of Keswick and Ambleside are within easy reach by car.

There are numerous small villages around the area with the occasional shop or public house. Picnic areas abound throughout the Lake District especially around the lakes themselves. Birds and other wildlife are plentiful. Scafell Pike is in the heart of the largest national park in England, which has 16 lakes within its area. The National Trust owns much of the land in the area.

When ascending Scafell Pike from Seathwaite via the Corridor Route, ample parking can be found in Seathwaite by the side of the road leading up to the farm where you start. You arrive there by passing 'Grange' at the southern end of Derwent Water.

The first sections of the walk from Seathwaite via the Corridor Route to the summit are good (photo 14) but it becomes progressively more difficult as you proceed, particularly in the latter stages climbing up towards the higher ground and the Pike.

Approaching Scafell foothills from Wastwater, there is a large National Trust car park (pay & display) over the small bridge on your right before you reach Wasdale Head, beside the campsite. A new car park is currently being constructed at Wasdale Head, a short distance further along the road. Currently, the village green at Wasdale Head is where most walkers park (2014-5). Continuing up the road to where the road ends a short distance further on past the end of the lake you will find Wasdale Head Hotel. Next to it is an outdoor shop, which has a small campsite opposite it (no facilities). All around here is mountainous with spectacular scenery.

When walking up to the col below Scafell Pike, you will see Great Gable on your left, with

Sty Head Tarn below (photo 24) and Derwent Water in the distance. This is the general direction of the Corridor Route which takes you to Seathwaite. Looking the opposite way you see Wastwater back down in the valley (photo 20). During darkness on moonlit nights, you can often see Wastwater and its reflection (photo 20). This will give you an unmistakable point to aim for on your descent during darkness. Take care to pick out your path carefully on a night descent. The route from Wasdale up to the summit during darkness is by far the easiest to walk and navigate, but leaving the summit in darkness or low cloud and descending off the pike itself can be a lot more difficult.

Whichever route you choose, use your map, GPS and compass wisely and accurately.

Take your waterproofs with you when visiting Seathwaite. This was once **the wettest place in Great Britain**, now superseded by Fort William!

Improvements planned for Wasdale Head during 2015/6.

1. New toilets for visitors
2. New car park on or near the village green

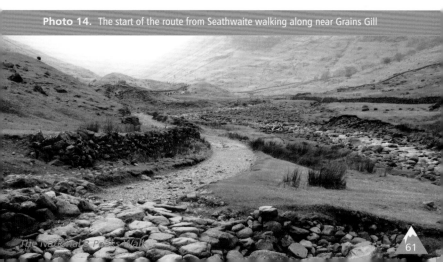

Photo 14. The start of the route from Seathwaite walking along near Grains Gill

The National 3 Peaks Walk

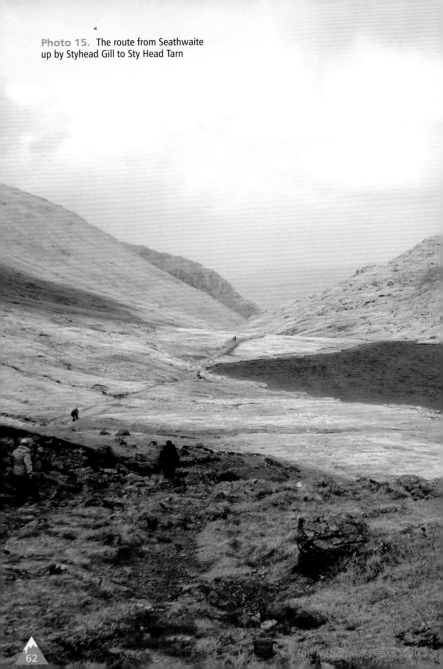

Photo 15. The route from Seathwaite up by Styhead Gill to Sty Head Tarn

The National 3 Peaks Walk

Scafell Pike - Via Wasdale Head – Grid References

Starting on the minor road at the bridge leading to the National Trust camping site and car park:

The route is undulating and winding so allowance must be made for this when walking and using the GPS.

Map to use is O.S. OL6 Lakes South-western area.

GR. 180076 Start
GR. 186072 Footbridge
GR. 193074
GR. 195074 Brown Tongue
GR. 205074
GR. 212078
GR. 215076
GR. 217074
GR. 215072 'Trig' point

Photo 16. Scafell Pike from the road near the National Trust campsite at Wasdale

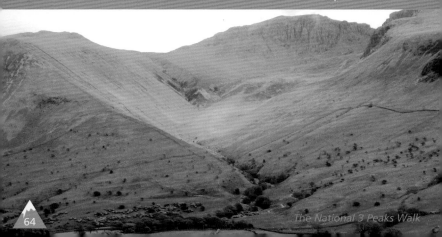

The National 3 Peaks Walk

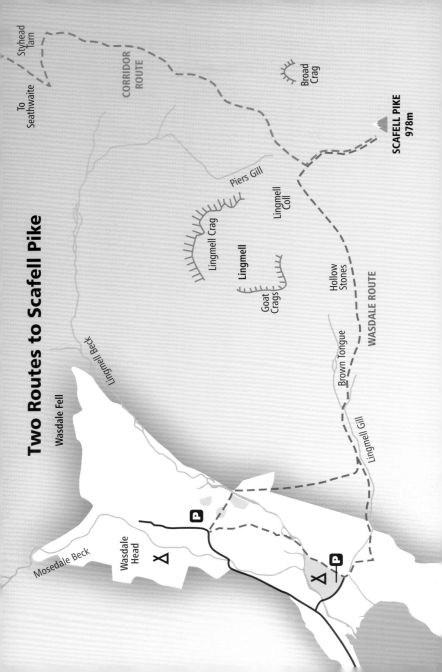

Two Routes to Scafell Pike

To Seathwaite

Styhead Tarn

CORRIDOR ROUTE

Broad Crag

SCAFELL PIKE 978m

Piers Gill

Lingmell Crag

Lingmell Coll

Lingmell

Goat Crags

Hollow Stones

Lingmell Beck

Wasdale Fell

Brown Tongue

WASDALE ROUTE

Lingmell Gill

Mosedale Beck

Wasdale Head

Walking Route - Scafell Pike
- Via Wasdale Head (Recommended)

Walking on the undulating road alongside Wastwater, a sign points to Wasdale Head. Turn right over the stone packhorse bridge as you come to the end of the lake (photo 16). A car park (pay and display) is located at the side of the National Trust campsite at the end of Wastwater. Your ascent of Scafell Pike begins here. A compass bearing from the National Trust car park looking directly to Scafell Pike is 98°M

Turn left out of the car park and walk up the stony farmers track. Cross over a cattle grid, then cross a bridge where the beck flows into Wastwater 100m further to the right. Turn left where a small wooden sign points to Eskdale, then up the right side of the beck.

Near a cottage, another sign says "Permissive Path, Scafell". The path passes the left side of the cottage.

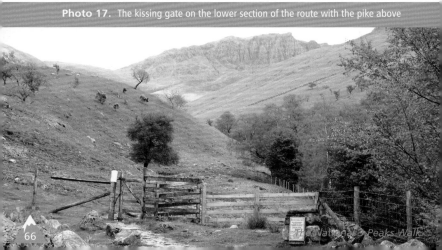

Photo 17. The kissing gate on the lower section of the route with the pike above

The National 3 Peaks Walk

About 100m past the cottage there is a footbridge, which crosses the small stream. Cross, then go through a gate, follow the path ascending to the right.

A sign states 'National Trust Property' and is next to a kissing gate (photo 17). Go through onto a narrow path, this is stony in places, winding its way up the mountain between the bracken on your left and the stream on your right. The path ascends steeply in places and numerous large rocks cover the path.

Looking back you can see Wastwater and the Irish Sea in the background beyond Workington Power Station. Scafell Pike is the sheer cliffs you can see directly ahead at the top of the valley (photo 17). Pass through another kissing gate with the beck still on the right. Continue up the very stony path.

A compass bearing taken just before Brown Tongue and in direct line to the Pike reads 98°M.

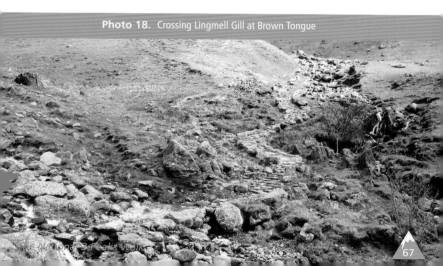

Photo 18. Crossing Lingmell Gill at Brown Tongue

You now come to a section of man-made cobbled path, which is easier to walk on. You can now see Brown Tongue and there is another section of cobbled path with a pile of stones formed into a cairn.

You now cross Lingmell Gill at the foot of Brown Tongue (photo 18), where you will see the path across the far side of the beck. Ascend the cobbled and stone path (photo 19) alongside another beck (photo 19).

A pile of stones further up mark a fork in the path; take the left path into heather and peat. The path turns stony soon after. You can see the path ahead but in parts it is not so well defined. The ground is flatter here with grass and lots of stones scattered around. Wind your way through and over the large stony area called Hollow Stones (photo 21) to join a path still ascending in the direction of the Pike.

There is a scree slope leading to Mickledore off to the right between the Pike and Scafell itself. It is a shorter route to the top but more dangerous to ascend or descend the scree slope, especially at night so it is recommended to stay on the main route.

Small cairns mark the main path (photo 22) which is small stone and shale with grass on both sides. There is a stone outcrop to the left side of the Pike. Skirt around the left side of it, looking for small cairns. Walk in a semi-circle to the large stone outcrop ahead (photos 22 & 23), and then look carefully to the right for the piles of stones on the final ascent

to the Pike.

Much of the remaining section consists of large stones, which you must walk over (photo 25). One slip and you could break an ankle between the stones, so take care here. Look to your left as you ascend, you should see Sty Head Tarn (photo 24), which is on the Corridor Route to Scafell Pike from Seathwaite. Beyond this tarn is Derwent Water.

On reaching the summit there is a triangulation pillar and a wind shelter. Views from the summit include the Scottish Borders, Blackpool and Windermere and on a clear night the lights of Douglas promenade on the Isle of Man can be seen.

The summit, as on any mountain peak, can be very cold with gale force winds. The wind chill factor should be taken seriously, so windproof clothing needs to be worn before reaching the summit.

On the return journey down the mountain pick out the path carefully especially in the dark. In the event of low cloud or loss of bearings on the summit, follow the bad visibility descent detailed in this book. On a dark but moonlit night the reflection of Wastwater is usually very evident and should help to point you in the general direction of Wasdale Head.

Walking Route - Scafell Pike
- via Seathwaite, (Corridor Route)

When you arrive at Seathwaite parking is available along the minor road just before the farm. Your ascent via the Corridor Route to Scafell Pike starts here.

As you start walking you go through a farm gate, continue on the path. Follow the path to a stile and gate; continue on the path into the distance going up the valley (photo 14). Cross a small wooden

bridge over the river. The path starts to ascend as you go up into the head of the valley. Following the course of the stream you come to a gate and stile. The path is undulating.

Cross the small but impressive stone packhorse bridge ahead. When you pass through the gate nearby, the path starts to ascend steeply. Go through a small gate between a stone wall, following the

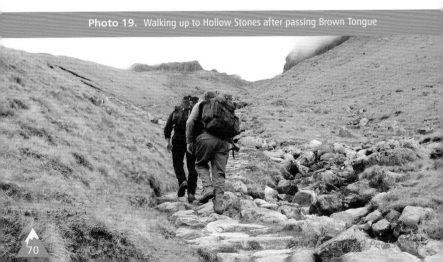

Photo 19. Walking up to Hollow Stones after passing Brown Tongue

obvious path.

Looking back at night towards Seathwaite you can often see a small light at the farm. This is a guide for any walkers returning at night by this route, especially in bad weather.

Approaching the head of the valley the path flattens a little. A waterfall runs on your right and the path becomes very uneven and turns slightly left between the head of the two hills. It is very important to keep the beck on your right because in extreme weather conditions there is a tendency to walk to the higher ground on the left then cross the beck onto the right side which is damp and boggy.

The path along by the beck is very uneven with large stones and is difficult to walk over. There is a cairn on the level area between the two hills. It may be surrounded by water in extreme conditions but is a good route marker. The cairn is approximately 80m from the wooden bridge

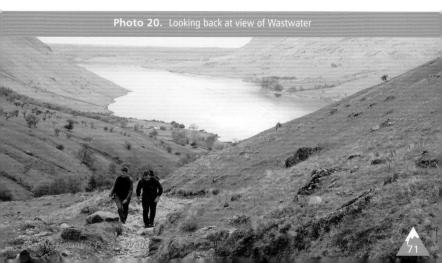

Photo 20. Looking back at view of Wastwater

you see ahead, following the rough uneven path.

Cross the bridge and the path is now on the right of the beck. In bad conditions it can be very wet. Walk up between the hills to another cairn on your left. Just past it cross the beck again still following the main path. There is a tarn on your left side called Sty Head Tarn (photo 15). Cross over another beck, the path is now better to walk on.

The path starts to divide nearing the head of the valley. It is important to head for the large rocks you see ahead. The path in parts here is grass. You come to a mountain rescue first aid stretcher box.

To this point the paths are reasonably obvious to see and follow but from here the path becomes difficult to see, walk along, and navigate to Scafell Pike. Take great care and constantly refer to map and compass.

Past the big stone, beside

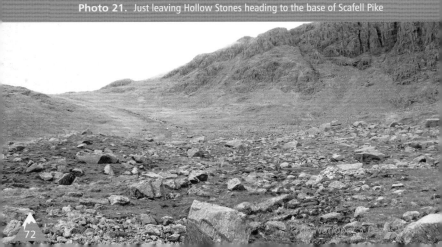

Photo 21. Just leaving Hollow Stones heading to the base of Scafell Pike

the "stretcher box" you bear left, descending slightly and cross over some marshy ground. You then rise up again over a grass area then drop down to the foot of the mountain, which is now straight in front of you. A magnetic bearing of 150°M from the stretcher box should take you across and up the side of the mountain along the Corridor Route.

Pick up a distinct path up the hillside, which is very steep in places with a drop off to your right.

Looking down the valley you can see Sty Head. The path winds its way to the summit and just before that, the path leads down and around to the left where there is a small cairn. The area is extremely steep and CARE should be taken. Go around the side of the waterfall known as Piers Gill. You pass another small cairn and some large rocks, which you walk between as you near the summit.

On the path there is a ravine with a waterfall.

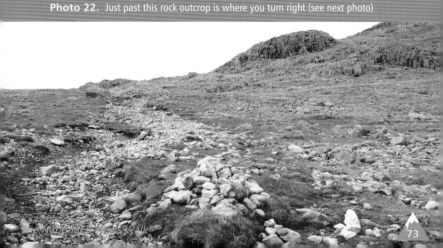

Photo 22. Just past this rock outcrop is where you turn right (see next photo)

You need to be careful where you are stepping. There is another distinct waterfall coming over the edge on the right with a steep drop down. Keep in to the left side of the path. You emerge at the foot of Scafell Pike at the base of Lingmell Col. The remaining section consists of large stones to walk over. Take care not to lose your footing, look for piles of stones marking the route to the summit.

It is up to you, the reader, to decide which route to choose. I prefer to walk up and return on the Wasdale/Wastwater route. This route is probably better for those who are not extremely skilled in map reading and using a compass. The Corridor Route is not recommended at night and especially in bad conditions. Once on the summit, if conditions are bad, follow the bad visibility descent detailed in this book.

The time to ascend to the Summit from Seathwaite is around 3¾ hours whereas from Wasdale head it is around 2¼ - 2½ hours.

Photo 23. The final approach to the summit

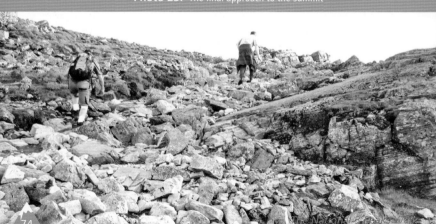

Driving Route To Snowdon

	Road		Destination
Leave Car Park	**Minor**	To	Santon Bridge
at Santon Bridge	**Minor**		Holmrook
at Holmrook	**A595**		Broughton in Furness
at Broughton	**A5092**		Haverthwaite
at Haverthwaite	**A590**	To	J36 of M6
J36 of M6	**M6**		M56 Chester
M56	**M56**		Queensferry A494
at Queensferry	**A55**		Llandudno Junction
at Llandudno Junctition	**A470**	To	Betws-y-Coed
at Betws-y-Coed	**A5**		Capel Curig
at Capel Curig	**A4086**		Pass of Llanberis

Park in main car park at Pen-y-pass opposite the youth hostel (pay & display). Alternative free parking can be found either in a lay-by heading towards Capel Curig or in a lay-by 1½ miles down the pass heading towards Llanberis. These lay-by's have limited parking space so try to look at mid-week events rather than weekends.

The distance by road is approximately 200 miles from Wasdale Head depending on which driving route you choose. Total drive time is about 4 hours. It is recommended that you change drivers regularly to avoid driver fatigue. Care should be taken to observe the speed limits. It is better to reach your destination intact.

Snowdon Routes

Llanberis Path

Paths converge

Glaslyn

Summit

Llyn Llydaw

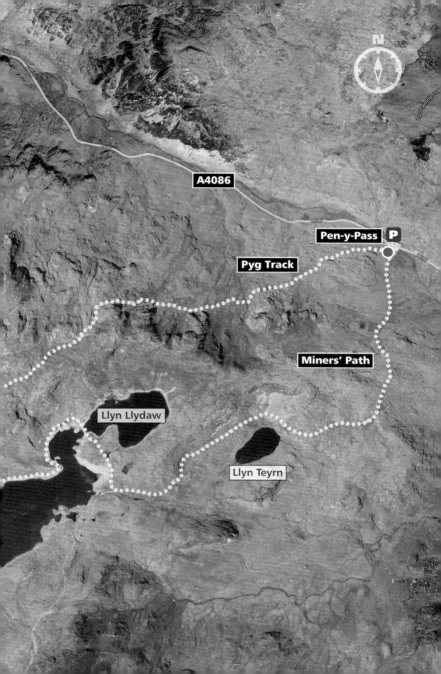

Snowdon Area

Mount Snowdon is situated in the Snowdonia National Park, covering an area of 840 square miles. The area around Snowdon is very mountainous, as you would imagine. The views all around the region are good and there are some picturesque villages within a short travelling distance.

The main recommended route is situated in the pass of Llanberis where it meets with Pen-y-pass. There is a youth hostel here and a mountain rescue post. Near Pen-y-pass there are a number of small lakes/tarns. The largest Llyn Llydaw is a reservoir.

The town of Llanberis is 6 miles away on the shore of Llyn Padarn or Llanberis Lake. Along the shore of this lake is a steam railway which is open to visitors. Probably the most famous tourist attraction in this area is the Snowdon Mountain Railway. This line starts in Llanberis and continues to the summit of Snowdon. It is Britain's only rack and pinion mountain railway.

On the summit there is a café (new in 2009) and gift shop where thirsty walkers can quench their thirst and purchase souvenirs. The café tends not to

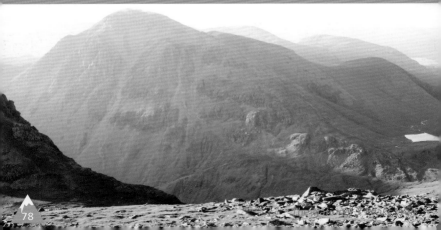

Photo 24. Looking towards Green Gable from Scafell Pike showing Sty Head Tarn

open before Easter if there is still snow on the summit as there usually is, or if the train cannot reach the summit because of snow. It is advisable to bring your own food and drink as the café may be closed!

Some walkers prefer to travel one way on the railway and the other on foot. (Check prices before you go if this is your preferred option.)

Throughout the area there are many tourist attractions but to do justice to them you need to spend a number of days exploring, walking and visiting all that the Snowdon area has to offer (see section on attractions). Betws-y-Coed and Caernarfon, are well worth visiting and only a few miles away.

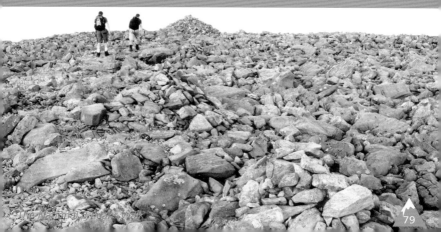

Photo 25. Near the summit on the rocky path with piles of stones to mark the way

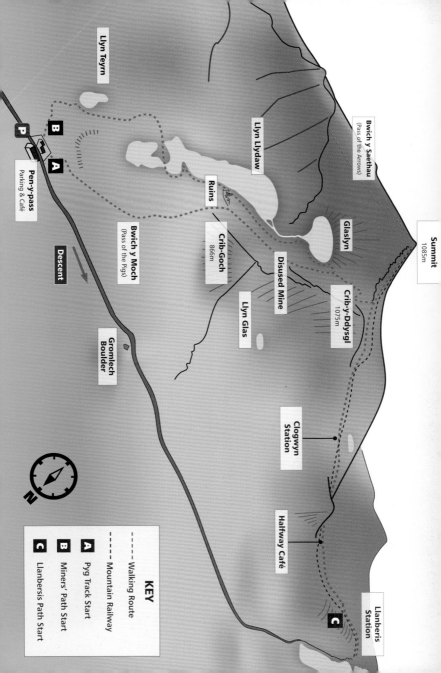

Snowdon Grid References

The route starts from the car park at Pen-y-pass on the Pyg Track, which joins the Miners' Track ¾ of the way to the summit. It finishes at the 'trig' point on Snowdon summit.

The route is both undulating and winding so allowance must be made for this when walking in low visibility.

Map to use is O.S. OL17 Snowdon

Starting at Pen-y-pass car park:

GR. 648556	**GR. 625548**
GR. 644555	**GR. 615549**
GR. 640554	**GR. 609549**
GR. 635554	**GR. 608547**
GR. 631551	**GR. 610544** 'Trig' Point

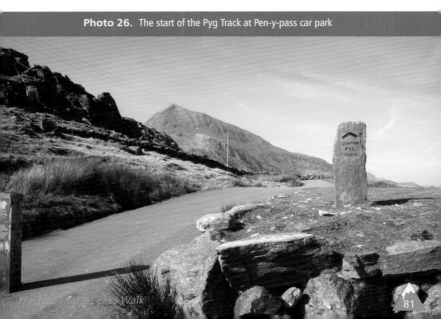

Photo 26. The start of the Pyg Track at Pen-y-pass car park

Photo 27. First view of Llyn Llydaw Reservoir
as you reach the col

YR
WYDDFA
SNOWDON

The National Trails Walks

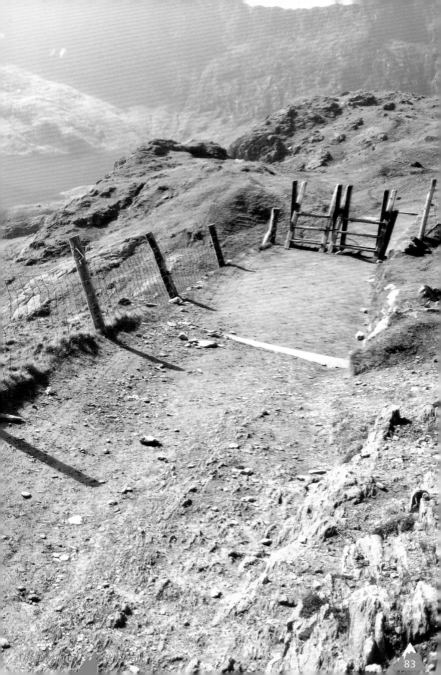

Walking Routes - Snowdon

There are 3 main starting points to climb Snowdon on the 3 peaks walk. The Pyg Track (photo 26) is the easiest and most popular; the others are the Miners' Track and the Llanberis Path, which ascends from the village of Llanberis. Lots of walkers ascend on the Pyg track and return on the Miners' Track.

Start A - The Pyg Track

Park at Pen-y-pass car park (charge) opposite the youth hostel near the top of Llanberis Pass. This car park can be very busy. Your ascent of Snowdon begins here (photo 26).

Your path is in the upper right hand corner of the car park, follow this undulating, winding path as you sometimes scramble up rocks to a stone wall with an opening between. There are good views from here into the valley. You will see the narrow slate path in front of you. The path ascends along the side of the mountain, it is very uneven with slabs of stone formed into steps.

You can see the obvious path winding up the mountain, keep to this undulating path.

You ascend to some posts and a wire fence as you reach the col, where there are good views of Crib Goch. Llyn Llydaw Reservoir can be seen in the valley (photo 27). As you look below, you will see the Miners' Track (photo 28), which is the alternative route back.

A slate-chipping path winds round through the Col as you are walking parallel with the small reservoir below, you then look into the next part of

the valley as you come over the step stile. There is another small tarn in view, tucked into the valley floor. The path is very evident along the next part of the valley, directly across is Snowdon with the Miners' Track below (photo 28).

A large expanse of stone, sloping to your left is in front of you, this can be very slippery when wet, and boots are advised. You have a good view of the second tarn in front. As you proceed, you see the third section of this path, which is undulating.

There are veins of quartz in much of the rock formations, which look like snow from a distance. There are the occasional piles of stones on route. As you pass a cairn on your left, the path is again scree.

The Miners' Track joins at a small stone post from the valley below and both paths continue together (photo 29). About 70m further up there is part of a disused quarry on your left, the path bears to the right.

The ascent now is steeper with a lot of loose stone and shale. You will see a monolith directly ahead at the col on the zigzag route (photos 30 & 31). At the head of this section there are large stone blocks to walk up. From the summit ridge, a water pipeline at the bottom of the valley can be seen.

The views once you reach the ridge looking towards Llanberis and in all directions are spectacular (photos 32 - 34). At the monolith on the ridge you turn left joining the Llanberis Path for the final

ascent. The path for the remaining distance to the summit is obvious; it runs parallel with the Snowdon Mountain Railway. As you approach you will see the café with the triangulation pillar on the summit nearby (photo 35).

You can go to the triangulation pillar for the customary photograph and viewing session. In the café there is time to relax over a variety of food and drinks while you look out and admire the views. A small souvenir shop is located inside the summit building.

You may wish to return to Pen-y-pass via the Miners' Track. This route takes you initially on a steep descent. After leaving the Pyg Track, the route is somewhat easier to walk for much of the way back (photo 36) before

becoming undulating in the last part. The return to Pen-y-pass by this route is as follows:

Retrace your steps to the monolith, and go down the zigzag path you ascended on. Just past this you should see a stone/scree descent off to your right by a small stone post (photo 29), leading to Glaslyn Tarn. Follow this path to the bottom taking extreme care. Once at the bottom follow the well-made track around the reservoir passing some ruined buildings on your left. Go over the causeway and past another tarn (photo 36). This path will take you back to Pen-y-pass car park.

This route is an enjoyable walk and takes approximately 1½ hours to return.

Start B - The Miners' Track

Park at Pen-y-pass car park opposite the youth hostel near the top of Llanberis Pass. This pay & display car park can be very busy. Your ascent of Snowdon begins here.

Your path is in the lower far corner of the car park. Go through the gate marked Miners' Track and continue on the good, undulating track, which winds clockwise around the mountainside. You arrive at Llyn Teryn, a small lake near the track and 1km further, you come to Llyn Llydaw reservoir. A causeway cuts across it.

Continue over the causeway and around on the track in the lower valley for a further 2km. The track ascends as you leave Llyn Llydaw (photo 36), passing former houses and industrial buildings of the Miners' on both sides on route, and then descends again to Glaslyn Tarn.

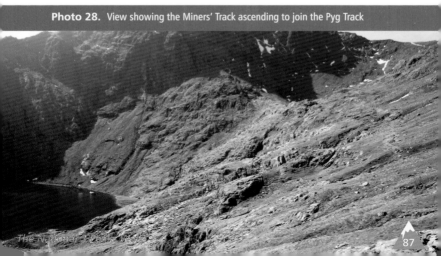

Photo 28. View showing the Miners' Track ascending to join the Pyg Track

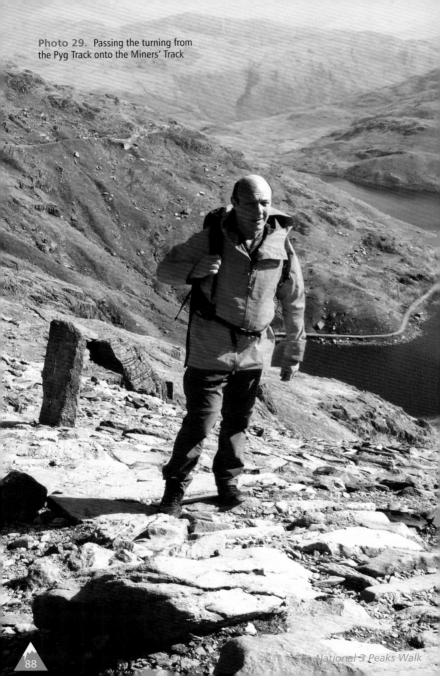

As you walk around the edge of Glaslyn Tarn, look for a worn track and sign on your right and steps up the steep mountainside (photo 28). Ascend here, where 500m further you come to another path by a small standing stone (photo 29), which is the Pyg Track. Turn left here and continue as described in start A.

The views from this point across to Snowdon and of the valley below are very good. Many people ascend via the Pyg Track then return via The Miners' Track which is, I feel, an easier path to return on, once you have descended to the lower ground. It is also safer in cold, low cloud and general bad conditions if you are walking on lower ground.

Photo 30. The steep ascent on the final approach to the ridge

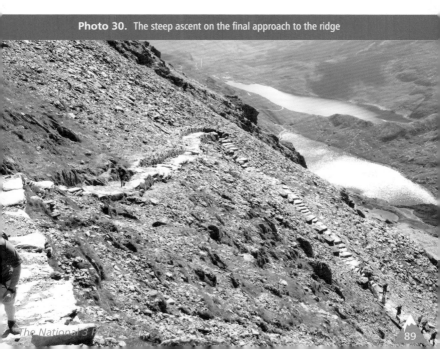

Start C - Llanberis Path

Park your vehicle in Llanberis and walk to the Royal Victoria Hotel near to Snowdon Mountain Railway. Opposite there are a number of tourist signs. One points to Snowdon Path. Follow this along the road before turning right, passing a row of houses. Cross the cattle grid at the far end and ascend the very steep metalled road to a holiday house/cafe just round a sharp bend. Continue through a metal swing gate onto a stone/shale path, still ascending steeply, to a sign pointing to Snowdon through a metal gate.

Ascend an obvious rough path. The first section of the path ascends steeply as does the last section. This path also has a lot of loose stone on it making walking difficult. The central section is on a slight ascent.

On the way up you pass under two small bridges

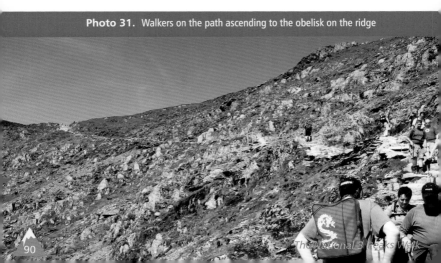

Photo 31. Walkers on the path ascending to the obelisk on the ridge

The National 3 Peaks Walk

carrying the Snowdon Mountain Railway (photo 34). You may see trains throughout the summer travelling up and down the line. You pass a café which is known as the Halfway House and is a convenient refreshment stop being approximately halfway to the summit.

Stay on the obvious path right to the summit. The top half of the route is very exposed in wet and windy weather. Nearing the summit you come to a large stone monolith on your left. This is where the Pyg Track and Miners' Track join in the final ascent. Continue parallel with the railway to the new summit café and the 'trig' point. Retrace your steps to return to Llanberis or alternatively descend on one of the other paths.

In the event of lost bearings or low cloud on the summit of Snowdon, follow the bad visibility descent to take you to safer ground.

Now you have conquered all 3 peaks of Scotland, England and Wales you can complete your challenge by driving to Caernarfon and touching the sea.

Optional Peak 1

Walking Route - Slieve Donard (Northern Ireland)

Start in Donard car park GR. 374305, walking from the rear of the car park stay on the right of the Glen River. Walk through Donard Wood where the path ascends for 150m to Donard Bridge.

Cross the bridge to the left side of the river and ascend for 400m to the next bridge, which you cross to take you to the other side again. Continue for 400m to a third bridge and 150m past it is a stile where the open area starts. It takes approx. one hour from here to the summit.

Continue on the obvious track and cross the river where it narrows. The path ascends steeply now for 500m, with a granite causeway up to the Mourne Wall. At this point Slieve Donard comes into full view and you can follow the wall to both Slieve Donard and Slieve Commedagh.

Ascend by the wall to the summit and return by the same route. The views from the summit are spectacular and include the Scottish mountains, Isle of Man, Mountains of NW England and Snowdonia in Wales.

Even though this mountain is the smallest out of the five, it can be very cold and inhospitable on the summit so ensure you are properly prepared.

The National 3 Peaks Walk

Slieve Donard - Useful Information

Situated

In the Mourne Mountains in the East.

Height

850 metres

Grid Ref

J 357277

How To Get There

Ferry

from - Stranraer
 Tel: 0870 5707070

 Liverpool
 Tel: 08444990007

Air

to - George Best Belfast
 City Airport

Website/booking
www.belfastcityairport.com

Belfast International Airport

Tel: 028 9442 2888

Bus

from - Belfast Europa
 Bus Station
 Tel: 028 3026 3531

Currency

The pound (£)

For Further Information

Kilkeel Tourist Information

Nautilus Centre
Rooney Road
Kilkeel
Northern Ireland
BT34 4AG

Tel. 028 4176 2525

Newry Tourist Information

Bagenal's Castle
Castle Street
Newry
BT34 2DA

Tel. 028 3031 3170

Newcastle Tourist Information

10 - 14 Central Promenade
Newcastle
Co. Down
BT33 0AA

Tel. 028 4372 2222

B&Bs

Widow's Row

161 South Promenade
Newcastle
Northern Ireland
BT33 0HA

Enniskeen Country House Hotel

98 Bryansford Road
Newcastle
Northern Ireland
BT33 0LF

Others may be available by contacting the T.I.C.

Heights of Surrounding Peaks

Slieve Commedagh 767m

Slieve Beg 590m

Slieve Corragh 640m

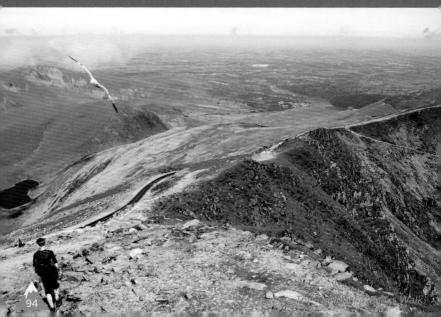

Photo 32. View towards Llanberis with the Pyg Track mid right and Llanberis Path

Optional Peak 2

Walking Route - Carrauntoohil (Southern Ireland)

The traditional "tourist route" up the mountain is quite straightforward generally, but with the Devil's Ladder section now badly eroded in places, this section needs extra care due to the loose stone. River crossings can present a problem in very wet weather, but the erection of bridges over the rivers and streams have helped a lot.

Allow 5½ - 6 hours for the round trip.

Start at Cronin's Yard (G.R. V837873). From Cronin's Yard follow the path until you meet the main Hag's Glen track shortly after the Gaddagh River crossing (GR.V827864) the river crossing can be extremely dangerous in high water and it can become swollen very quickly. In wet weather it may be safe crossing in the morning but lethal by the afternoon.

Continue into the Hag's Glen, crossing the ford at Grid Ref. V821854 (can also be dangerous when swollen) and walk between Loughs Gouragh and Callee. After ascending a short rise the path becomes less distinct as it crosses waterlogged ground before arriving at the foot of the Devil's Ladder. The Devil's Ladder is a steep gully consisting of loose scree and boulders. It is unstable in places and care should be taken, particularly when icy or in wet weather. Ascend the main gully and do not veer to the sides. On the ascent be very aware and watch for loose stones and rocks

being dislodged by other walkers.

When you reach the col at the top of the Devil's Ladder, turn right onto the long summit slope of the mountain. The path is feint at first but becomes more prominent as you ascend. There are various paths leading off the main path but they all lead eventually to the summit.

In poor visibility beware of heading too far to the left of the track to the dangerous ground above Curraghmore, or too far right where a narrow track leads across the face of the mountain towards the 'Heavenly Gates'.

Return via the same route or the Brother O'Shea's Gully route.

Photo 33. View showing the Pyg Track and Miners' Track in the distance

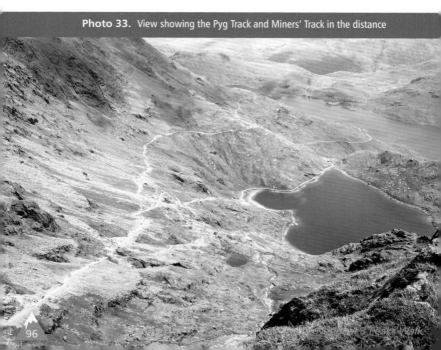

Carrauntoohil - Useful Information

Situated

County Kerry.
Nearest main town - Killarney

Latitude/Longitude:

52.02335°N / 9.68582°W

Height

1038 metres

Map Used

O.S. IRELAND 1:50,000
Discovery Series No 78

Start/Finish Grid Ref

Cronin's Yard
(G.R. V837873)

How To Get There

Approximate journey times
to Killarney by Car:

Dublin to Killarney:
300km (4 - 5 hours)

Rosslare Harbour to Killarney:
280km (4 hours)

Galway to Killarney:
190km (2 hours)

Cork to Killarney:
90km (1 hour 15 minutes)

From Killarney drive towards
Beauford/Gap of Dunloe
following the "Ring of Kerry"
to the Hags Glen, close to the
town land of Carhoonahone.
At a small countryside junction
you will see Kissane's shop and
a telephone box. Take the road
on the left, at the end of which
is a small farmyard with a car
park (charge).

If asking directions, ask for
"Cronnin's Yard".

Bus Éireann run a number of
express services to Killarney.

Rail Killarney is connected to all
the other major cities in Ireland
by rail.

Ferry

Fishguard to Rosslare

Hollyhead to Dublin

Currency

The Euro (€)

For Further Information

Tourist Information

Killarney Discover Ireland Centre
Beech Road
Killarney
Kerry
Republic of Ireland

+353 64 6631633

killarneytio@failteireland.ie

B&Bs

Killaran House Guesthouse

Park Road
Killarney
Kerry
Ireland

Tel: Local 0646637286
International
00 353 646637286

Sunnybank

Fairhill
Killarney
Kerry
Ireland

Tel: Local 064 6634109
International
00 353 64 6634109

Heights Of Surrounding Peaks

Macgillycuddy's Reeks Area

Binn Chaorach 1,010m

Cathair na Féinne 1,001m

Cnoc na Péiste 988m

Cathair Thiar 975m

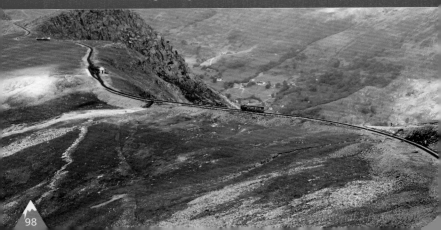

Photo 34. View along the ridge towards Llanberis with the Llanberis Path in centre

Bad Visibility Descents

During the ascent of any mountain care should be taken especially in bad visibility.

More accidents happen on the return journey than on the ascent. It may be difficult to pick out the path of descent in low cloud or in darkness. In situations like this follow the bearings and details below to ensure a safe descent from the summit.

..

Ben Nevis

Walk from the triangulation pillar on a grid bearing of 225° for 120m. **Caution – Do Not Veer to the Right!**

Follow a grid bearing of 287° for 60m, which should take you clear of the plateau onto your path.

Approx. grid bearing 280° for 800m follow winding path. Stay on path, **do not take bearing more than 281°**

The compass bearing is gained by adding the magnetic difference to the grid bearing, this is known as a magnetic bearing. Refer to current O.S. map for magnetic variation.

Scafell Pike

Walk from the triangulation pillar on a grid bearing of 315° for 300m. Look carefully for the path and cairns.

Walk for 200m on grid bearing 294°

Walk for 200m on grid bearing 336°

Then walk on grid bearing 231°

From this point follow the descending path around to the left, towards Brown Tongue.

This route takes you to the left of Dropping Crag, down to Lingmell Col and left around to Hollow Stones.

The compass bearing is gained by adding the magnetic difference to the grid bearing. Refer to current O.S. map for magnetic variation.

Following this course from the summit should bring you off the peak and below the rocks in front of the Pike itself. From this point you can follow the path downhill to Wastwater looking for the piles of stones on route.

Snowdon

Walk from the summit station/café on grid bearing 347° for 500m following the distinct path. A railway line is on the left and a steep drop on the right. At the monolith turn right on grid bearing 48°. You are now on another distinct path going downhill. This path zigzags sharply (photo 30). Stay on this path to descend, eventually leading back to Pen-y-pass. In extreme bad weather follow the railway line down into Llanberis.

In the event of low cloud or other problem on the top half of the route, the Miners' Track will take you to the valley quicker. It starts about a third of the way down the mountain by a small standing stone (photo 29) and branches off to the right.

The path is steep at first but once at the bottom it is a good path to Pen-y-pass. A sign is situated at the Pen-y-pass end of this track giving current weather conditions.

The compass bearing is gained by adding the magnetic difference to the grid bearing. Refer to current O.S. map for magnetic variation.

Support Team

When attempting the National 3 Peaks it is advisable to have a support team of 2-4 people who are able to drive between the 3 peaks and provide the food and drinks to tired walkers. It is not advisable for walkers to both attempt the 3 peaks and drive between each area. The general tiredness of driving the long distances between each mountain and the walker's fatigue makes it essential to have a support team of more than one person.

Providing food and warm drinks to walkers is very important especially in bad conditions. The last thing walkers need on returning to the foothills of each peak is to start preparing food and drinks themselves.

Members of any support team should have some knowledge of first aid and should be able to recognise the symptoms of exposure. They should be aware of the location of the mountain rescue posts and nearest telephone for emergency. The support team should keep a spare rucksack ready to take with them in emergency with the following inside:

- Map
- Compass
- Whistle
- Emergency Food/drink
- Survival Bag
- Notepad/Pencil
- Spare Clothing
- First Aid Kit
- Sleeping Bag
- Torch (spare bulb/batteries)
- Mobile Telephone (not guaranteed to function in mountainous areas)

Where possible, there should be two of the support team who are experienced and prepared to give assistance to any of the walkers in an accident/emergency situation. It may be decided that the best course of action is to go straight to the aid of a walker rather than contact the mountain rescue team initially. Any potential risks to either the injured or lost walker or the rescuer should be carefully considered before deciding your course of action.

Below is a checklist of things support staff should consider:

a Will you have food and drinks ready for the walkers when they arrive back at the vehicle after completing each mountain?

b Are all the drivers insured to drive the vehicle?

c If the vehicle breaks down do you have AA/RAC or similar cover to help get you home?

d Do all the support team including drivers, cooks etc know the places they are going to, distances and what is expected of them on the trip?

e Are there one or two fit support people who could go onto the mountain to assist a walker who needs help if they are called, and do they have the required knowledge and equipment? (see information above)

f Do you have check sheets to check walkers out and in at each stop and to record times etc?

g Do you have knowledge of where the nearest mountain rescue is and location of relevant emergency services as well as where toilets are at each start and car parks?

h Have you studied the map and route you will be travelling beforehand?

i Do you have a list of contact phone numbers for all walkers and next of kin, in case of emergency? (mobile phone signal permitting!)

Going for Help

If at some point you need to go for help, raise an alarm or need to telephone for help then it is important that you have the following information if possible:

• The location of the injured person

• Name of the casualty

• Nature of injury

• Experience level of the injured person and group

• Number of people in the group

• Clothing injured person is wearing or some recognizable item. This is important in cases of helicopter rescue.

The National 3 Peaks Walk

Useful Information

Heights Of Peaks

Ben Nevis 1344 metres
Scafell Pike 978 metres
Snowdon 1085 metres

Nearest Main Towns

Ben Nevis
• Fort William

Scafell Pike
• Keswick (northeast)
• Whitehaven (west)
• Ambleside (east)

Snowdon
• Llanberis

Nearest Telephone

Ben Nevis
• Beside Glen Nevis Youth Hostel
• Glen Nevis Visitor Centre
• Ben Nevis Inn

Scafell
• Wasdale Head Hotel
• Farms and houses at base of Wastwater
• Seathwaite Farm and nearby houses in emergency

Snowdon
• Pen-y-pass Café
• Llanberis
• Café on Snowdon Summit

Mountain Rescue Posts

Ben Nevis
• Fort William Town Centre

Scafell Pike
• Wasdale Head
• Keswick Mountain rescue
• Mountain Rescue Kit near Sty Head on the Corridor Route

Snowdon
• Pen-y-pass
• Nant Peris in Pass of Llanberis

Recommended Maps

Ben Nevis
O.S. Explorer No.392 Ben Nevis & Fort William (1:25,000)

Scafell
• O.S. Explorer No.OL4 North West English Lakes (1:25,000)
• O.S. Explorer No. OL6 South West English Lakes (1:25,000)

Snowdon
• O.S. Explorer No.OL17 Snowdonia (1:25,000)

The National 3 Peaks Walk

Weather Information

Ben Nevis Area
- www.mwis.org.uk (national)
- www.bennevis.org

Scafell Area
- 08700 550575

Snowdon Area
- 09068 500449

General Weather
- www.metoffice.gov.uk
 (click on "mountain weather")

The forecast for Ben Nevis is displayed on the notice board near the start. For Snowdon, it is displayed in the window of Llanberis T.I.C. each day.

Grid References

Ben Nevis

- Glen Nevis Visitor Centre
 GR. 123730
- Glen Nevis Youth Hostel
 GR. 128718
- Halfway point on main path, near Lochan Meall An t-Suidhe
 GR. 147724
- Emergency shelter, Ben Nevis summit
 GR. 167713

Scafell Pike

- Wastwater, Wasdale Head car park
 GR. 180076
- Base of Scafell Pike
 GR. 207074
- Scafell Pike summit
 GR. 215072
- Sty Head Tarn, Corridor Route.
 GR. 221099
- Seathwaite car park, Corridor Route.
 GR. 235422

Snowdon

- Pen-y-pass (near youth hostel) car park
 GR. 648556
- Start of Llanberis Path
 GR. 581595
- Snowdon summit
 GR. 610544

Average Timing For Each Mountain

Ben Nevis

- Visitor Centre start to summit 3½ - 4½ hours
- Summit to Visitor Centre 2¾ hours
- Youth Hostel start to summit 3¾ hours
- Summit to youth hostel 2¾ hours

Scafell Pike

- Wasdale Head start to summit 2 - 2¾ hours
- Summit to Wasdale Head 2¼ hours
- Seathwaite, start to summit 3¾ hours
- Summit to Seathwaite 3¼ hours

Snowdon

- Pen-y-pass, Pyg Track start
 to summit 2¼ hours
- Summit to Pen-y-pass,
 returning via Miners' Track 1¾ hours
- Llanberis Path to summit 2½ hours
- Summit to Llanberis 1¾ hours

These timings will vary depending on the skill and fitness of your party
e.g. Ben Nevis can be completed in 4½ hours with ease for some walkers.

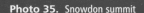

Photo 35. Snowdon summit

The National 3 Peaks Walk

Suggested Itinerary - 24hr Challenge

1600	touch water - Fort William
1630	start base of Ben Nevis
1845	summit of Ben Nevis
2030	base of Ben Nevis
0200	start base of Scafell Pike
0445	summit of Scafell Pike
0615	base of Scafell Pike
1230	start base of Snowdon
1430	summit of Snowdon
1530	base of Snowdon
1600	touch water – Caernarvon

To achieve these times, walkers need to be fit and walk/jog at a fast pace up/down each mountain. This can lead to hypothermia, exhaustion and accidents as walkers try to achieve the 24 hour challenge. It is not recommended, as you will get a more rewarding experience following the times below, with less chance of accidents.

A Weekend Challenge - Alternative

Saturday

start	0200	Glen Nevis Visitor Centre
	0600	Ben Nevis summit
	0830	Glen Nevis Visitor Centre
start	1630	Seathwaite or Wasdale - Lake District
	2000	Scafell Pike summit
	2230	Wasdale Head

Sunday

start	0800	Pen-y-pass-Snowdon
	1015	Snowdon summit
finish	1230	Sunday Pen-y-pass car park

Starting at 2am in Glen Nevis will mean that you should get to Scafell Pike and ascend and have started the descent at least before darkness.

The National 3 Peaks Walk

National Park / Tourist Information Centres

- Glen Nevis Visitor Centre
 01397 705922

- Fort William T.I.C.
 Information Line
 0845 2255121

- Keswick Information Centre
 017687 72645
 08459010845

- Llanberis T.I.C.
 01286 870765

- Betws-y-Coed T.I.C.
 01690 710426

- Caernarfon T.I.C.
 01286 672232

Attractions In Each Area

Ben Nevis Area

- Crannog Cruises
 01397 700714

- Nevis Range Cable Cars
 01397 705825

- Ben Nevis Distillery
 01397 702476

- Ben Nevis Highland Centre
 01397 704244

- West Highland Museum
 01397 702169

- Lochaber Leisure Centre
 01397 704359

- 'The Jacobite' Steam Train
 01524 737751

Scafell Area

- Keswick Launch
 on Derwent Water
 017687 72263

- Cumberland Pencil Museum
 017687 73626

- 'The Theatre by the Lake'
 - Keswick
 017687 74411

Snowdon Area

- Snowdon Mountain Railway
 0870 458 0033

- Electric Mountain
 01286 870636

- Llanberis Lake Railway
 01286 870549

- Padarn Country Park
 01286 870892

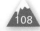

Local Radio Stations

These are useful to get the weather forecast just before you start.

Fort William

Nevis Radio on 96.6 - 102.3 FM

Lake District

Radio Cumbria on 104.1 FM

Snowdonia

The local forecast for Snowdon is displayed in the window of the Tourist Information Centre in Llanberis each day.

Useful Addresses / Telephone Numbers

Long Distance Walkers Association

Paul Lawrence
15 Tamarisk Rise
Wokingham
Berkshire RG40 1WG

Tel 01189 790190

This association is set up to further the interests of those who enjoy long distance walking. Members receive a journal three times each year (Strider), which includes information on all aspects of long distance walking.

Website – www.ldwa.org.uk
Email LDP@ldwa.org.uk

Ramblers Association

2nd Floor, Camelford House
87-90 Albert Embankment
London SE1 7TW

Tel. 0207 3398500

Advice and information on all walking matters. Local groups hold regular meetings.

Rail Services to Fort William

www.scotrail.co.uk

03457 484950

Public Transport Information for Fort William

0871 2002233

www.threepeakspartnership.co.uk

This is a new partnership set up to manage the mountains and primarily to help the sustainability of each area and preserve them for future generations to enjoy.

Pen-y-pass car park

If you cannot park your vehicle in Pen-y-pass car park and you need to park near Llanberis, there is a taxi service which will pick you up where you park and take you back to pen-y-pass car park for a small fare.

Phone CK-Cabs (Taxi based in Llanberis) on 01286 871768.

A Park & Ride from Llanberris to Pen-y-pass is now also available.

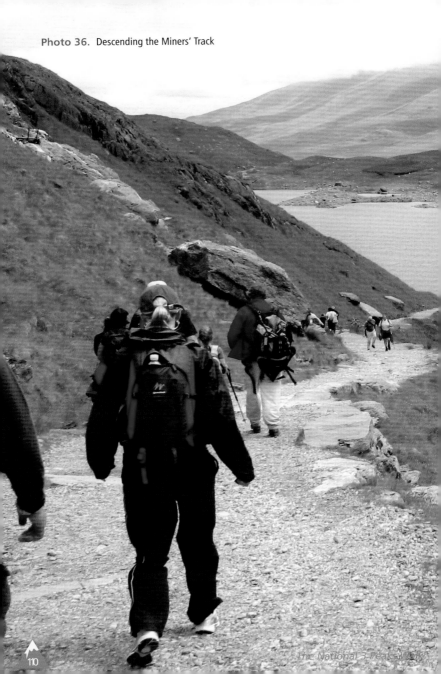

Photo 36. Descending the Miners' Track

The National 3 Peaks Walk

Accommodation

The following selection of accommodation for each area is not arranged in any order of priority. All are within reasonable distance to the walking routes.

Ben Nevis Area

Campsite

Glen Nevis Caravan & Camping Park
Glen Nevis,
Fort William
01397 702191

Glen Nevis
Self Catering Log Cabin & Flat
Margaret Ferguson
'Harland'
Glen Nevis
Fort William PH33 6ST
www.bennevislogcabins.com
contact@kennyferguson.co.uk
01397 705905

Bed & Breakfast

Sandra Mackinnon
Constantia House
Fassifern Road
Fort William PH33 6BD
www.constantiahouse.co.uk
constantia.house@yahoo.co.uk
01397 702893

The Brevins Guest House
Glen Nevis
Fort William
PH33 6PS
www.thebrevins.co.uk
info@thebrevins.co.uk
01397 701412

Debbie Black
Fassfern Guest House
Achintore Road
Fort William
PH33 6RQ
www.fassfernguesthouse.co.uk
enquiries@fassfernguesthouse.co.uk
01397 704298

Myrtle Bank Guest House
Achintore Road
Fort William
PH33 6RQ
www.myrtlebankguesthouse.co.uk
enquiries@myrtlebankguesthouse.co.uk
01397 702034

Youth Hostel
Glen Nevis Youth Hostel
01397 702336

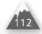

Scafell Area

Campsites

Seathwaite Farm
017687 77394

Wasdale Head (National Trust site)
019467 26220

Youth Hostels

Wasdale Hall Youth Hostel
019467 26222

Borrowdale Youth Hostel
0870 7705706

Bed & Breakfast

Burnthwaite Farm
Wasdale Head

Seascale

Cumbria.

CA20 1EX

www.burnthwaitefarm.co.uk

bookings@burnthwaitefarm.co.uk

019467 26242

Snowdon Area

Campsite

Ty Isaf,
01286 870494

Youth Hostels

Pen-y-pass 0870 7705990

Llanberis 0870 7705928

Bed & Breakfast

Erw Fair
High Street

Llanberis LL55 4HA

www.erwfair.com

erwfair@fsmail.net

01286 872400

Glyn Afon
72 High Street

Llanberis LL55 4HA

www.glyn-afon.co.uk

info@glyn-afon.co.uk

01286 872528

Llanberis Lodges
High Street

Llanberis

LL55 4EN

www.llanberislodges.co.uk

info@llanberislodges.co.uk

01286 871617

Post Walk

After achieving your goal of walking The National 3 Peaks, an individual mountain or the 5 peaks challenge, you may like a certificate or other souvenir to mark your achievement. The author has produced a list of souvenirs below. If you have any questions then please email.

National 3 Peaks Walk & New 5 Peak Challenge Souvenirs

Prices correct for 2016. Check website for up to date prices for future years. All items are post free.

Coloured Embroidered Cloth Badge (Triangular) Depicting all 3 peaks - **£2.40 (see photo)**

Triangular Enamelled lapel Pin Badge 30mm each side
***Best seller!*- £2.40 (see photo)**

Nat. 3 Peaks Colour Triangular Car Sticker, 130mm with peaks names - **£1.25**

Ben Nevis Colour Triangular Car Sticker 130mm with name & height.
- £1.25 (see photo)

Certificates - All £1.45 each

All certificates are produced on quality hammered ivory card

Certificate for completing all 3 Peaks Ben Nevis, Scafell Pike, Snowdon. ***Best seller!***

Certificate for Driver/Support cooks & helpers to recognise their effort.

Certificate for completing the ascent of Ben Nevis only.

Certificate for completing the ascent of Scafell Pike only.

Certificate for completing the ascent of Snowdon only.

New! Certificate for any combination of peaks (please specify by email).

Certificate for completing the 5 peak Challenge. All 5 peaks included.

Certificate for completing Slieve Donard in Northern Ireland.

Certificate for completing Carrauntoohil in Southern Island.

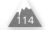

A Pictorial Walk up Ben Nevis, 220 Photos of the entire route on CD - **£3.00**

A Pictorial Walk up Scafell Pike from Wasdale, 150 photos of the route - **£3.00**

A Pictorial Walk up Scafell Pike from Seathwaite, 226 photos of the route - **£3.00**

A Pictorial Walk up Snowdon, Over 148 photos of each of the 3 main Snowdon routes (photos) on separate DVDs (specify route) - **£3.00**

Film DVD, (35 mins) The route to the summit of Ben Nevis **Best seller! - £6.00 (see photo)**

You can order books and souvenirs on our website **POST FREE** at **www.chall-pub.co.uk** or by sending for a current price list enclosing a S.A.E. to:

**Brian Smailes
Challenge Publications
7 Earlsmere Drive
Ardsley
Barnsley
South Yorkshire S71 5HH**

For queries Email:
challengepublications@yahoo.co.uk

Alternatively, scan the QR code to the right using a barcode reader app to access the website directly on your smart device.

Ben Nevis Film DVD

Metal Pin Badge
Size: 30mm

Embroidered badge - 95mm
Car sticker (same design) - 130mm

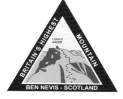
Ben Nevis car sticker - 130mm

The National 3 Peaks Walk

The 3 Peaks Club of Great Britain

Once you have completed the 3 Peaks you are eligible to join **The 3 Peaks Club of Great Britain.**

There is no membership fee now and you will be kept up to date with any new developments regarding the 3 peaks, routes, roads and safety as well as general information and offers by way of a newsletter emailed to you approximately once or twice a year.

Your details will NOT be passed on to any other party.

Please email challengepublications@yahoo.co.uk with all names, and email address of all who completed, stating when you completed all 3 peaks.

You can order souvenirs from the 3 and 5 peaks souvenir list on previous pages including certificates for you to complete to certify when you climbed and completed the event.
The website to order from is:
www.chall-pub.co.uk

The route described in this book was used by the author in 2015 and believed to be correct at the time of publication. Hopefully you have enjoyed your 'National 3 Peaks' walk and gained much pleasure from it.

Should you wish to walk other challenging routes, please visit Challenge Publications website at:

www.chall-pub.co.uk

Or the National 3 Peaks website

www.national3peaks.co.uk

A wide selection of walking and other guides covering the UK are available including:

- The Yorkshire 3 Peaks Walk
- Hadrian's Wall
- The Lyke Wake Walk
- John O'Groats to Lands End (Walking)
- Lands End to John O'Groats (Cycling)
- The 1066 Country Walk
- The Isle of Wight Coastal Footpath

These books, like this one contain everything you need to know to complete the challenge. See full list in front of book.

On our website you will find other walks around the British Isles which are equally as picturesque and enjoyable as the National 3 peaks.

Should you wish to comment on this book or give further information to help keep the book updated then please write to the address below or e-mail via the web site. An acknowledgement will be given.

Please write to

**Challenge Publications
7 Earlsmere Drive
Ardsley
Barnsley
South Yorkshire S71 5HH**

E-mail:
challengepublications@yahoo.co.uk

Glossary

B&B - Bed and Breakfast.

Bearing - A degree or number of degrees set on a compass then follow the direction of travel arrow to walk on that bearing to reach your intended destination.

Beck - A stream or brook.

Burn - Scottish word meaning stream, brook, beck or watercourse.

Cairn - An ancient stone mound erected as a marker. Often modern day piles of stones that denote a path or route are referred to as cairns.

Col – The lowest point on a mountain ridge between two peaks. May also be called a notch, a gap or a saddle.

Crag - A steep rugged rock or peak.

Dyke, Dike, Ditch - Words used to denote a long ridge of earth or a water channel either raised up or below normal level.

Escape Route - Used for any emergency situation or in times of bad visibility. The main aim is to get you down to lower ground by the safest but quickest way.

Glen - Scottish word for a valley.

G.P.S. - Global Positioning System.

Grid Reference - Derived from the National grid reference system. This is used to pinpoint a place on a map by the use of letters and numbers, written as GR. _ _ _ _ _ _

Gully - A narrow channel or cleft in a rock face. May have waterfalls, can be very slippery and have vertical drops.

Kissing Gate - Swing gate that usually lets one person through it at a time by moving the gate backwards and forwards.

Loch - Scottish word for lake.

Lochan - A small landlocked mountain lake.

Magnetic Bearing - This is a grid bearing taken from a map and the relevant magnetic variation added to it to obtain the magnetic bearing. See relevant maps for detail of current magnetic variation.

Metalled Road - Generally known as a stone-chipping road. This term became known as the roads metal or the roads surface.

Outcrop - Part of a rock formation that protrudes from the main body of rock.

Path - A narrow path of grass, mud, stone etc. suitable for walkers. Not usually more than 2m wide.

Plateau - A wide and mainly flat area of elevated land.

Summit - The highest point of a mountain or hill.

Scree – loose stone and shale.

Tarn - A small landlocked mountain lake.

T.I.C. - Tourist Information Centre.

Track - A road (possibly rough) usually wide enough for a vehicle and often leading to a farm. Usually more than 2m wide.

Trig Point - True name is triangulation pillar. These mark the summit of many mountains, but not every mountain has one. It is a small stone pillar with a number on it. The height of the mountain is taken from this point.

Scan the QR code below using a barcode reader app to access the website on your smart device:

- **Have you organised the National 3 Peaks Walk or another walk?**

- **Are you a charity or raising money for a charity?**

- **Are you confident you can lead the group and get walkers safely to the finish?**

- **Do you need help with organisation?**

- **Would you like us to organise and guide the walk for you?**

- **Would you like to walk the National 3 Peaks as part of an organised group?**

Outdoor Challenge Events can provide the help and advice you need from basic advice to organizing and leading the full event for groups or individuals. Qualified guides transport and all food stops catered for. Best rates. We organize this 3 peaks walk each year as well as many other UK and worldwide.

If you are walking as an individual or as a team, check out the website and contact us.
www.outdoorchallengeevents.co.uk

You can sign up to do the challenge for a charity of your choice, or just pay to come along. Special group rates are available.

e-mail
info@outdoorchallengeevents.co.uk
and let us know your requirements.

We are the experts and will get you safely from start to finish. Let us organise the event for you.